West Coast
Weather Vanes

Garret & Peggy Wyner
Hummingbird & Flowers Weather Vane - 2014

We hope this book enhances your appreciation of the
Art of the weathervane and that you consider
your weathervanes every bit as special as these
classic examples of American Folk Art.

LizAnne & Ken Jensen
West Coast Weathervanes

THE ART

OF THE

WEATHERVANE

by Steve Miller

Schiffer Publishing Ltd ®

4880 Lower Valley Road, Atglen, PA 19310 USA

Copyright © 1984 by Steve Miller
Library of Congress Catalog Number: 83-51742

Printed in China.
ISBN: 0-88740-005-1

Published by Schiffer Publishing Ltd.
4880 Lower Valley Road
Atglen, PA 19310
Phone: (610) 593-1777; Fax: (610) 593-2002
E-mail: Info@schifferbooks.com
Please visit our web site catalog at **www.schifferbooks.com**

In Europe, Schiffer books are distributed by Bushwood Books
6 Marksbury Avenue Kew Gardens
Surrey TW9 4JF England
Phone: 44 (0) 20-8392-8585; Fax: 44 (0) 20-8392-9876
E-mail: info@bushwoodbooks.co.uk
Free postage in the UK. Europe: air mail at cost.

This book may be purchased from the publisher.
Include $3.95 for shipping. Please try your bookstore first.
We are always looking for people to write books on new and related subjects.
If you have an idea for a book please contact us at the above address.
You may write for a free catalog.

Dedication

This book is dedicated to my wife Toni for her patience and assistance in its preparation and to all those collectors who look at weathervanes not as artifacts or collectibles, but as serious examples of American Folk Sculpture. May their numbers increase!

Acknowledgements

I wish to thank the following collectors and dealers for their assistance and for sharing their knowledge and photographs to make this endeavor possible: Marna Anderson, New York City; David Davies, New York City; Dorothy Kaufman, New York City; Betty & Bob Marcus, Palm Beach, Florida; Kenneth & Ida Manko, Moody Point, Maine; Frank & Karen Miele, White House, New Jersey; Samuel Pennington, Waldoboro, Maine; Marty & Estelle Shack, Bellemore, New York; and the numerous Private Collectors who have requested anonymity.

Table of Contents

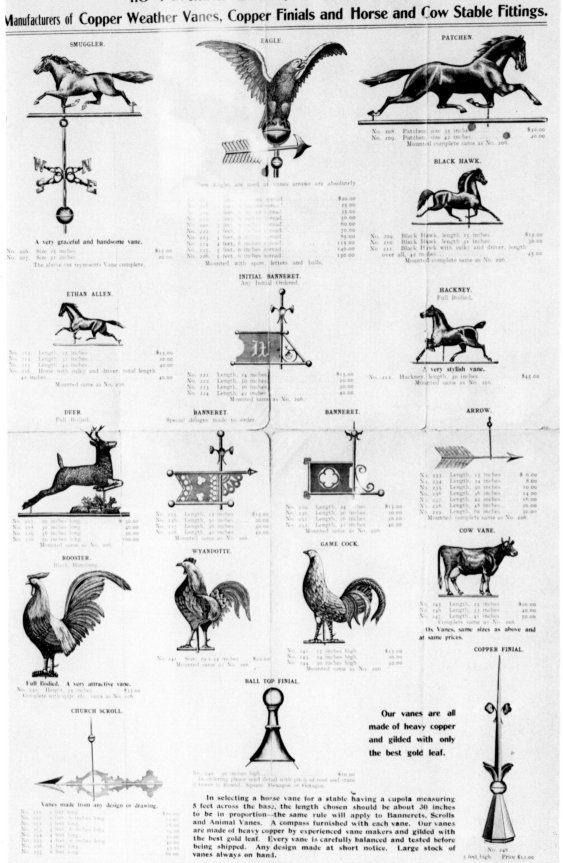

Advertising, Broadside of Puritan Iron Works.

Introduction

There are many types of collectors. Over the centuries, men and women have collected coins, stamps, guns, swords, and more recently, decoys, cars and even airplanes, but the collector of weathervanes is a different breed. He is primarily an Art Collector. While the stamp, coin, and decoy collector may have hundreds of specimens in his collection, the weathervane collector may have three. The collector of weathervanes may also collect paintings, wooden folk sculpture, and painted country furniture.

While the collector of stamps, coins and decoys collects to possess, the collector of weathervanes collects to *see* and appreciate. He enjoys looking at beautiful objects, not merely possessing them. The collector of decoys will *usually* only buy a working decoy that was carved for use in the hunt. The collector who buys a weathervane is buying sculpture and form, and its use and function are only secondary to its beauty.

It was not until early in this century that the American weathervane was collected and considered to be an art form. Picasso himself considered the American weathervane a great work of art. Among the early collectors of American weathervanes were such artists as Nadelman, Kuniyoshi, Demuth, and Laurent, who appreciated them as examples of American Folk Sculpture.

Although weathervanes date from the earliest times, and American weathervanes from the late 17th Century, we will be dealing primarily with those which reached their highest form from the beginning of the 19th Century until the first quarter of the 20th Century.

Because weathervanes were designed to perform a functional purpose, their development as an art form was gradual and unintentional. This is true of all great naive art. Indeed, a careful examination of European weathervanes will indicate a lack of sculptural quality in the naive sense. While *early* examples of American weathervanes bear a great resemblance to their European counterparts, due primarily to the strong influence of immigration; as years and generations passed, this influence waned and a truly native sculpture appeared.

This, however, does not mean that all 19th Century American weathervanes are great works of art. In fact, the reverse is true. Many of the weathervanes that one sees available on the market and in many collections should be classified as artifacts rather than art.

What separates art from the artifact is difficult to put in writing. It is primarily an opinion based upon how one *looks* upon an object and how one *sees* that object. Beauty is many things to many different people, and one should look upon a weathervane as one looks at any sculpture. First and foremost, one looks at the form. One should then look at the patina of age and the results of many years of exposure to the elements, and what this has done to the surface of the weathervane.

While the collector of coins, stamps, and decoys places great value on specimens in mint, that is, new condition, and worn, battered examples have little value; with a weathervane the reverse is true. The form and beauty often are greatly enhanced by the ravages of nature upon its surface.

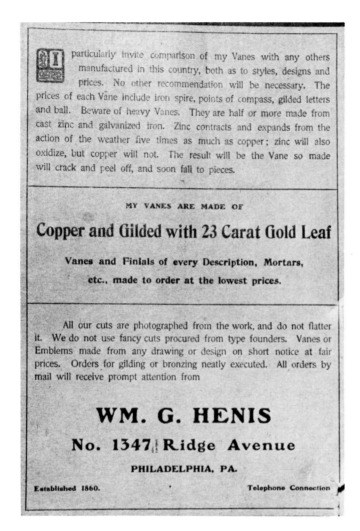

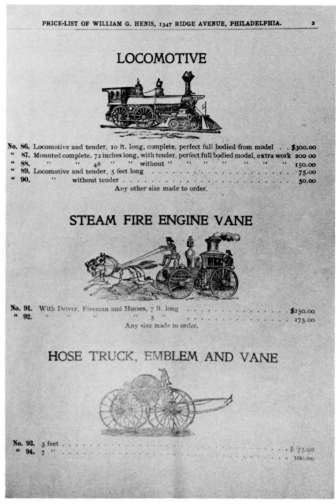

Frontpiece and page from catalog of William G.
Henis, Philadelphia. Circa 1880.

Weathervanes are composed of two basic groups. The best known are the so-called factory-made weathervanes, which can be either two or three dimensional. They are usually made of copper, but can be made of zinc, tin, iron, brass, or a combination of some or all of these metals. The weathervane factories first appeared in the mid-19th century, reached their greatest number during the last quarter of that century, and began to disappear in the first few decades of the 20th century.

While some purists deride the artistic quality of the factory weathervane, it is important to note that there is often more handwork in the manufacture of a factory weathervane than in any bronze sculpture. In fact, the making of a factory weathervane begins with a carved wooden model, much like a clay original used by Frederick Remington; and while a bronze is simply poured into a mold, the weathervane must be hand-hammered into several molds, cut, soldered together, carefully filed, and then gilded.

It is unfortunate that not much is known about the artists who designed and carved the original models for the factory weathervanes. It is also unfortunate that many of the companies copied the designs of their competitors so well that it is often impossible to correctly attribute the makers of some weathervanes. In many cases however, we can correctly attribute the maker by comparing design, construction methods, and finish to *known, signed* examples. It is also interesting to speculate on why the makers signed some but not all of their output. Logic seems to indicate that when they sold a weathervane directly to the consumer, they would sign their work; but when they sold through a distributor or agent, the vanes would not be signed. It makes sense that the owner of a hardware store would not want the buyer to be able to deal directly with the factory.

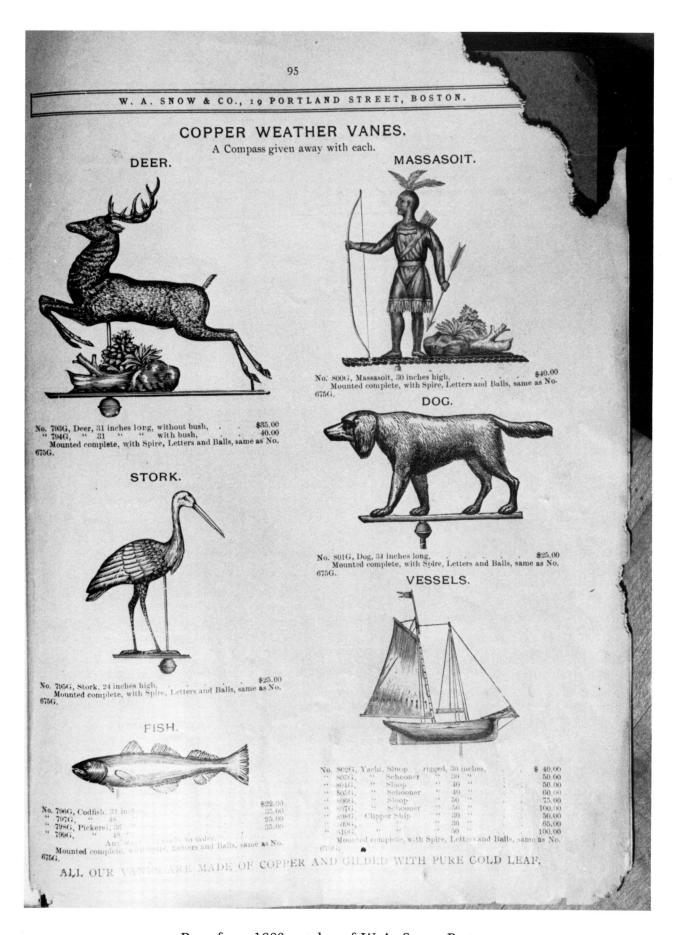

Page from 1880 catalog of W.A. Snow, Boston.

The second group of weathervanes that we will consider, is the individually-made weathervane. It is usually two dimensional, but can be three dimensional, is usually made of a wooden plank or of sheet iron, but can also be made of zinc, tin, copper, brass, or a combination of these materials.

These weathervanes were usually made by the farmer or homeowner who indeed depended upon a weathervane to forecast weather changes. He either could not afford or chose not to buy the factory product; and the result was often more beautiful than any that could be bought in a store.

For the collector who cannot afford the often extremely expensive examples of factory weathervanes, this is an area in which a collector can build a beautiful collection at a modest cost. While it is true that some one-of-a-kind vanes have sold for five figures, the vast majority of sheet iron or wooden vanes can be bought for under $2,500.00.

The subjects of these one of a kind weathervanes will vary as much as those made by the factories; but the more common forms, such as horses, cows, roosters, arrows, and banners are easier to find. It is important, however, to remember that we are dealing with art; and the beauty of the form is far more important than what the form represents. I have often heard a collector only show interest in what the form represents, ie: a horse, cow, etc., rather than the beauty of the sculpture itself. The collector who looks at a "Index" horse weathervane by Jonathan Howard and replies, "I already have *a* horse" should collect stamps. A Volkswagon and a Ferrari are both cars, but there the similarity ends. The collector should be far more interested in the art of the form, rather than whether or not a factory made it, or what sort of animal or object the vane represents.

The collector who wishes to build a collection should do so slowly. He should read, look and appreciate. He should be prepared to buy quickly but carefully. The *great* piece that comes onto the market does not remain there for long. While this might seem like a contradiction in terms, it is not.

He should also remember that he cannot own every weathervane; and he should not want to, since they are not all art. He should buy each weathervane for its beauty rather than its rarity. The Boar, Elephant, Lion, and Buffalo weathervanes made by J.W. Fiske in the late 19th century are all great rarities, but I have yet to see one that is beautiful. The collector should not seek to buy *one* of each form, ie: a horse, cow, bull, pig, etc. A collection of four beautiful horse weathervanes is infinitely superior to one which places emphasis on different forms rather than beautiful forms.

The collector can choose to buy from a dealer, another collector, or at auction. All of these methods entail some risks, but these are easily minimized. Probably the riskiest method is to buy at auction. Unless the auction is the estate or collection of a good collector, the buyer often will find himself purchasing the mistakes that dealers have made. At an auction, he will often pay far more than he would pay to buy the same weathervane from a dealer, either at a shop or at an antiques show. The auction buyer is often given a false sense of security because of the competitive nature of the place. He feels that if the weathervane was not worth the price which it brings, the underbidder would not have gone so high. The collector who likes a piece at auction would be far more prudent to consult with a dealer he has confidence in; and ask for and pay for if necessary, advice on how high to bid. This way, he will avoid the pitfall of ending up with some dealer's "mistakes", often at a price far higher than he would have paid buying directly from that dealer.

The collector who refuses to pay a fair price will build up a collection of rejects, fakes, and worked-over items. If he thinks that he will build a great collection by driving the back roads of New England and buying weathervanes for a *song* he is mistaken. Twenty years ago that was possible, not today. Great weathervanes on New England buildings are scarcer than the number of Corots in those same buildings.

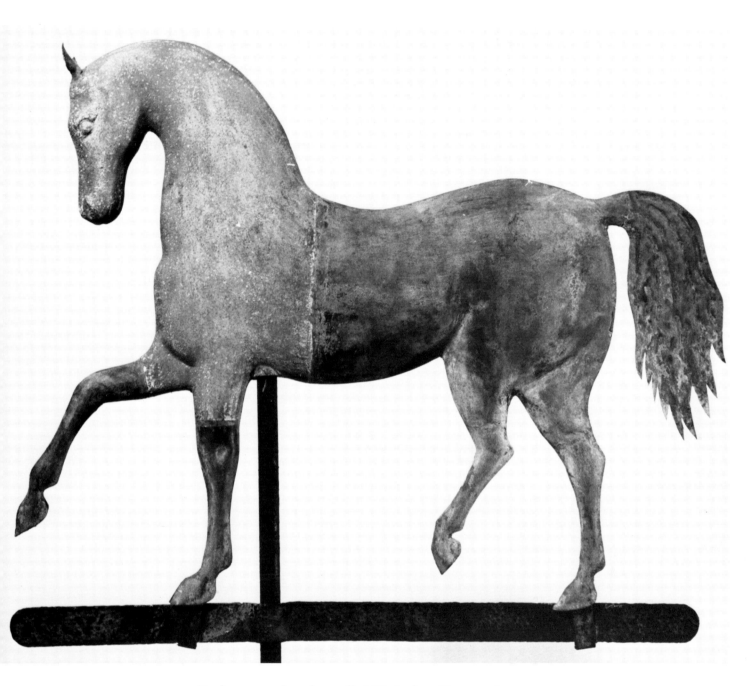

Early example of small 18" Index Horse, circa
1855: Collection of Howard Feldman.

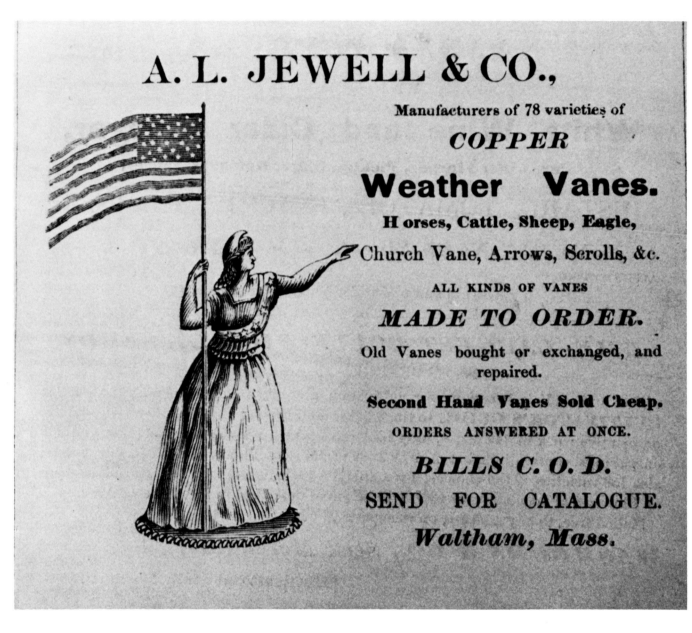

Ad of A.L. Jewell & Co., circa 1864.

Chapter 1

Factory Weathervanes

One of the oldest and probably the most important factory weathervane-makers was the firm of Jonathan Howard & Co., of West Bridgewater, Massachusetts. Howard was born in 1806, and was engaged in business as a vinegar-maker and pickle-preparer for over twenty years, until approximately 1850, when he began producing a small selection of weathervanes. While listed as a factory weathervane maker, Howard in fact had less than six employees, and his small output is generally regarded as the most beautiful and most

WHOLESALE PRICE LIST OF VANES

MANUFACTURED BY

J. H O W A R D & C O.,

WEST BRIDGEWATER, MASS.

Large Cow,	(Swelled)	$30 00	Horse and Gig,	(Swelled)	$18 00
Small "	"	17 00	Horse leaping Hoop	"	19 00
Large Ox,	"	22 50	Lady Suffolk Horse,	"	15 00
Small "	"	14 00	Cod-Fish,	"	16 00
No. 1 Horse,	"	9 00	Grey Hound,	"	16 00
" 2 "	"	13 00	Plow,	(Plate)	14 00
" 3 "	"	16 00	Locomotive,	"	12 00
Large Rooster,	"	15 00	No. 1 Fancy,	"	9 00
Small "	"	5 00	" 2 "	"	9 00
Large Peacock,	"	14 00	" 3 "	"	10 00
Small "	"	4 00	" 4 "	"	8 00
Large Deer,	"	17 00	" 5 "	"	8 00
Small "	"	4 00	" 6 "	"	12 00
No. 1 Church Vane, 4 ft. 3 in. long,		28 00	Large Dart,	"	7 50
" 2 " " 4 ft. 9 in. "		32 00	Small " No. 1,	"	5 00
" 3 " " 5 ft. 9 in. "		45 00	" " " 2,	"	5 00
" 4 " " 6 ft. 3 in. "		50 00	Academy Vane,	"	17 00

All Vanes manufactured by Howard & Co. are warranted Copper, and gilded with the best Sign Gold.

Price list of J. Howard and Co., 1854.

desireable of all the factory-made weathervanes. Very little is known about his firm, and while no catalog has ever been found, a price list dating from approximately 1855 shows the available forms. The weathervanes by J. Howard are easy to identify, since Howard used cast zinc for the entire front end of his output, unlike most makers who used castings only for the head. In addition, the design of the Howard weathervanes shows the most stylization of any of the factory-makers. His "Index" Horse is almost Oriental in its grace. On occasion, his Vanes will be stamped *Made by J. Howard & Co. W. Bridgewater Mass.* In addition to the "Index" Horse, Howard also produced Roosters, Cows, Bulls, Deer, Peacocks, and a few other forms, some of which have not yet surfaced.

In 1868 Howard's business was taken over by Horatio L. Washburn, who operated the business as *H.L. Washburn & Co.,* but the form and style of Howard's weathervanes were discarded, and Washburn's output was virtually identical to that of most of the other makers. It seemed that Howard's weathervanes had a major fault for the times. Their gold leaf would wear faster on the zinc portion of the weathervane, and thus require more frequent re-gilding or painting than a Vane made entirely of copper, since the fashion of the times required the more gaudy look of the Golden Horse or Cow.

For beauty and stylization, the only maker who rivaled Howard was *A.L. Jewell & Co.,* of Waltham, Massachusetts. Jewell operated a small factory from the early 1850's until his untimely death in 1867, when he fell from a painting platform. Jewell's weathervanes are even more

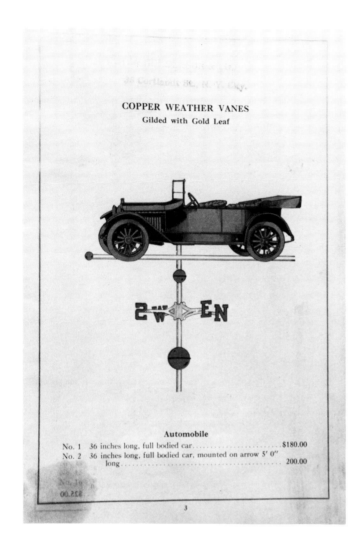

COPPER WEATHER VANES
Gilded with Gold Leaf

Automobile

No. 1 36 inches long, full bodied car.....................$180.00
No. 2 36 inches long, full bodied car, mounted on arrow 5' 0"
 long.. 200.00

3

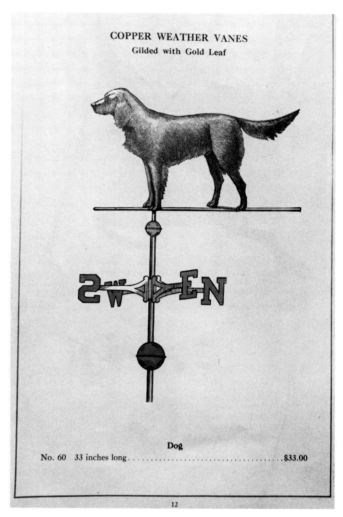

COPPER WEATHER VANES
Gilded with Gold Leaf

Dog

No. 60 33 inches long...................................$33.00

12

Pages from 1928 catalog of Washburn Weather-
vane Co.

stylized than those of Howard, but are far more
primitive in design and lack the classic look of the
Howard product. They are occasionally found
stamped *A.L. Jewell & Co. Waltham, Mass.* on
the side. Another characteristic of the Jewell
product was the large amount of lead used in the
soldering process.

Upon Jewell's death, his equipment, molds, and
designs were purchased by Leonard W. Cushing &
Stillman White who formed the company of
Cushing & White and continued in the manu-
facture of weathervanes.

While very litte is known about the men who
designed most factory weathervanes; it is known
that some time in 1867, Cushman engaged a
Henry Leach of Boston, a wood carver and a
cabinet maker to carve some original weathervane
patterns. The only three examples known are
those of "Ranger" a Setter Dog, now in a private
collection; "Black Hawk" a trotting horse, also in
private hands; and a large figure of Liberty in the

Frontpiece of catalog of L.W. Cushing & Sons,
1883.

14

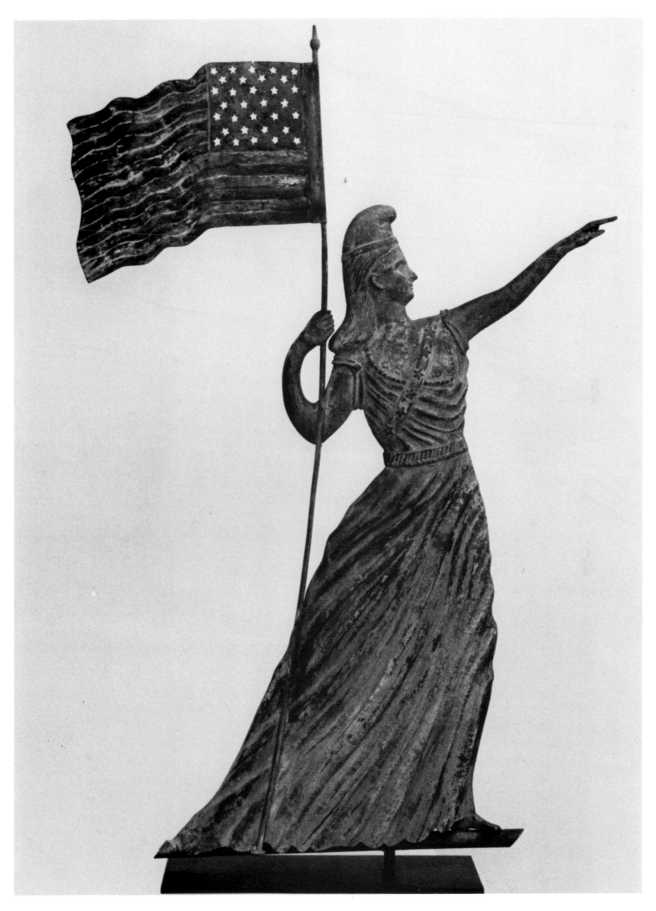

Frontpiece; Goddess of Columbia, A.L. Jewell &
Co.: Private Collection.

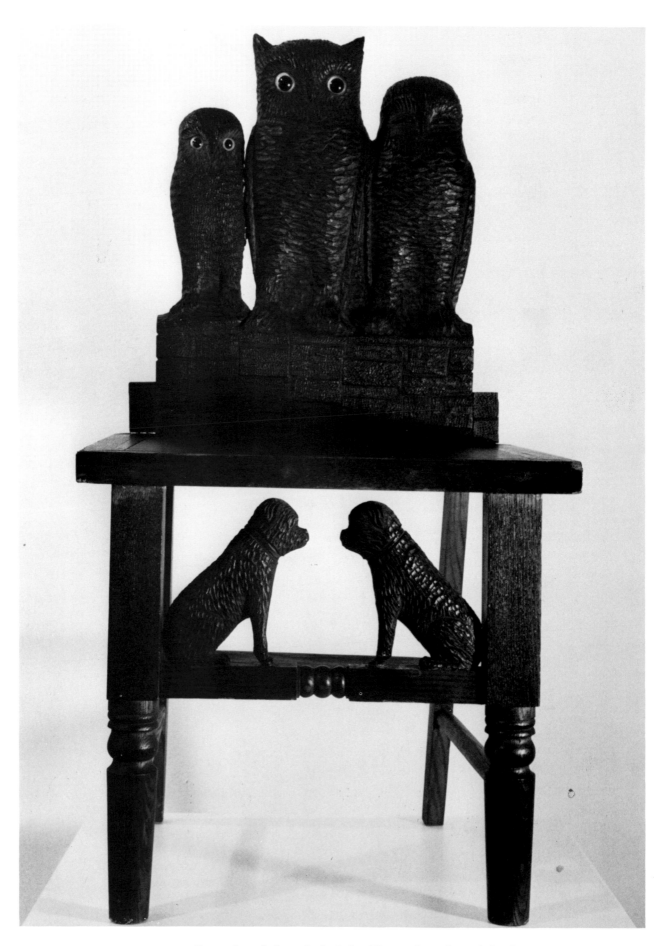

Carved and signed chair by Henry Leach, original
designer and sculptor for L.W. Cushing & Co.

16

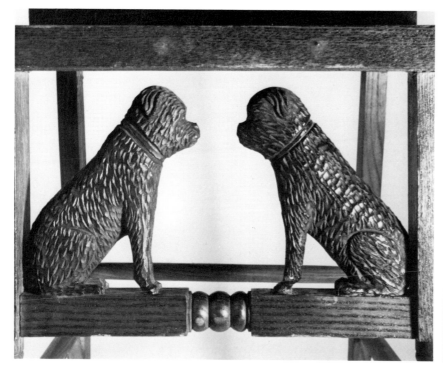

Detail of chair shown on preceding page.

collection of the Shelburne museum. A carved and signed chair by Leach with fully carved dogs and three owls is also in a private collection; and the style and execution is identical to that of the weathervane forms.

After White sold out in the 1870's, the firm was known simply as *L.W. Cushing & Co.*, and then later as *L.W. Cushing & Sons.* Cushing & White's weathervanes are often signed with the firm's name and address on a small oval tab found soldered to the crossbar.

In 1868, Josephus Harris of Brattleboro, Vermont established a weathervane factory under the title *Boston Weathervanes,* which later was named simply *Harris & Co.,* and was located at 111 Kingston Street in Boston. Among Harris' Boston competitors was the *Puritan Iron Works* at 110 Portland Street and *W.A. Snow & Co.* at 19 Portland Street. Both firms based their patterns on those of Harris, and unless they are signed, it is next to impossible to establish one from the other.

The New York weathervane makers can be listed together, since they all seem to be copies of each others patterns, and their catalogs almost appear to be identical in design, construction and price. They are *J.W. Fiske & Co., Samuel Bent & Sons, Thomas Jones, J.L. Mott Iron Works, A.B. & W.T. Westervelt Co., and D. Dorendorf.*

While there were numerous weathervane makers during the latter 19th century from Pennsylvania to Michigan, the importance of the maker is secondary to the beauty of the object. Most makers provided stamped parts which they would sell unassembled to their competition, and some of these *factories* probably were actually only assembly plants.

The most common form of factory weathervane was the Eagle. The American Eagle, our nation's symbol, was produced in large numbers by all of the factories, and in most cases are so similar in appearance and construction that it is impossible to identify the maker. The two exceptions are the eagles by A.L. Jewell & Co., and the eagle by Jonathan Howard. Both are exceptionally stylized and fierce in appearance, and are constructed with the typical early heavy zinc and lead applications.

The next most common weathervane form is the Horse, which is found in numerous models and stances. Some are modeled after famous Trotting Horses of the 19th Century, with Ethan Allen, Dexter, and Mountain Boy being the most common. Black Hawk, the famous trotter of Morgan stock, is a beautiful example of the weathervane art. Most of the makers used the Currier and Ives prints in their design; and these

17

famous Trotters were often fitted with Sulky or oddly enough, with a jockey. In addition to the Trotters; farm horses, Morgan Horses, Steeplechase horses and standing horses are also found.

The next most common form found is the Rooster weathervane, found also in the Game Cock example. All of the Companies made Roosters in different styles and sizes; and aside from the rare example by Howard & Jewell, again, it is almost impossible to identify the lineage.

Cows, Bulls, Oxen, Ewes, Rams, and Pigs and even Goats completed the Farm animals available; and Deer, dogs, foxes, Indians, and almost anything else could be purchased to point into the wind in the 19th Century. The 20th Century brought with it Automobile and Airplane weathervanes, as well as Fire apparatus, Locomotives and even bicycle Riders.

A careful examination of weathervane catalogs will show that often weathervanes took the place of a trade sign; and the dairy would sport a cow weathervane, the pig farmer a hog, a blacksmith a plow. From the Fiske catalog of 1883 and a Dutchess county greenhouse, we even find a Shovel weathervane. The very rare figure of Columbia holding the American Flag is occasionally found, and even less often, a figure of the Statue of Liberty.

The major weathervane companies would produce just about any form to order, and thereafter picture that form in their catalogs, which often leads the casual observer to think that a specific form was mass produced while perhaps only one or two actually were.

A perfect example is the Buffalo or Bison weathervane which was made to order by J.W. Fiske for Bucknell University in Lewisburg, Pennsylvania. Those few examples, which to this day are still at Bucknell, are the only known Bison weathervanes, but all post 1883 Fiske catalogs show the form.

↑ Cover and two pages from 1880 catalog of Harris & Co., Boston.
→

18

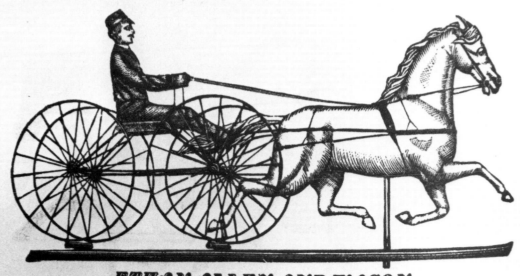

ETHAN ALLEN AND WAGON.

No 3, $50 00
" 3, and sulky 40 00

These prices include Vane, Spire, Letters and Balls, all complete.

Manufactured by HARRIS & CO., 111 Kingston Street, Boston, Mass. 13

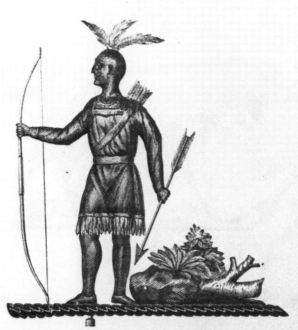

MASSASOIT.

30 inches high $40 00

These prices include Vane, Spire, Letters and Balls, all complete.

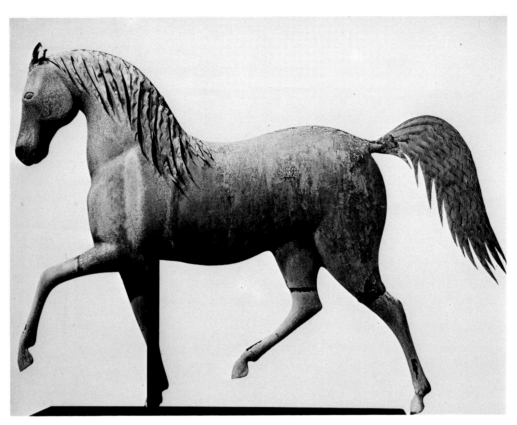

Medium sized 24" Index Horse by J. Howard &
Co., signed: Private Collection.

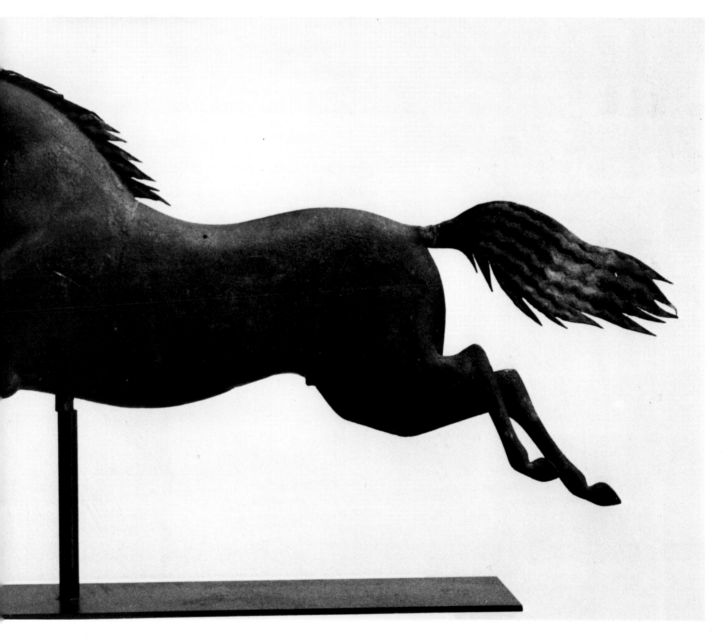

Exceptionally rare Running Horse by J. Howard &
CO., 36" overall: Collection of Dorothy Kaufman.

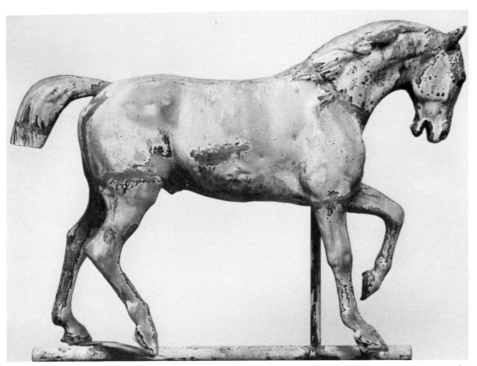

Hackney version of Morgan Horse by W.A. Snow.
36" overall: Private Collection.

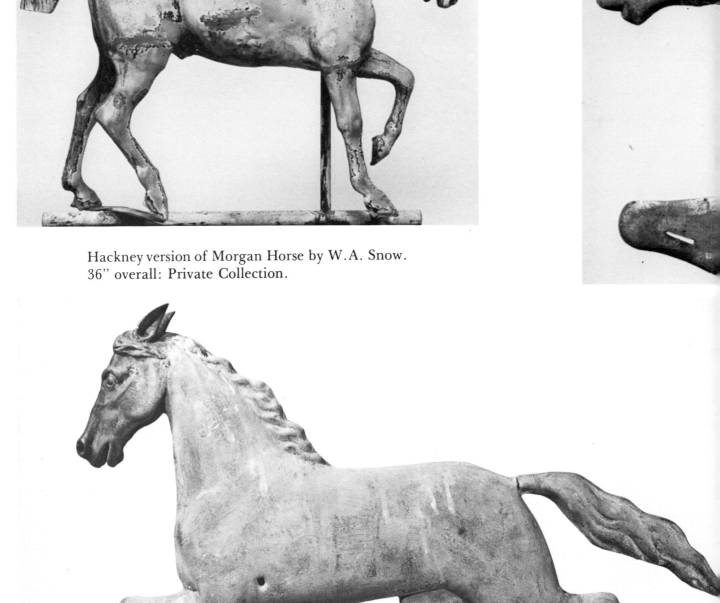

36" Running Horse by Harris: Private Collection.

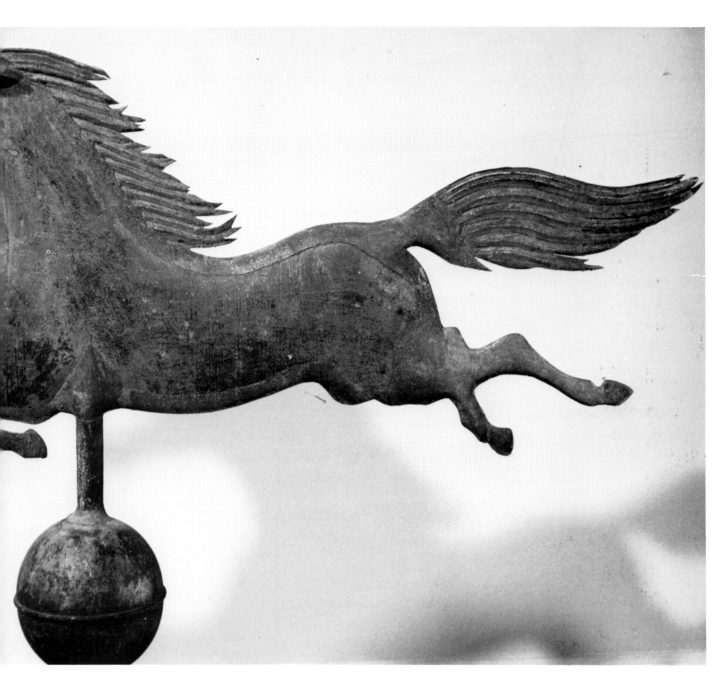

"Flying Horse" by A.L. Jewell & Co.: Private
Collection.

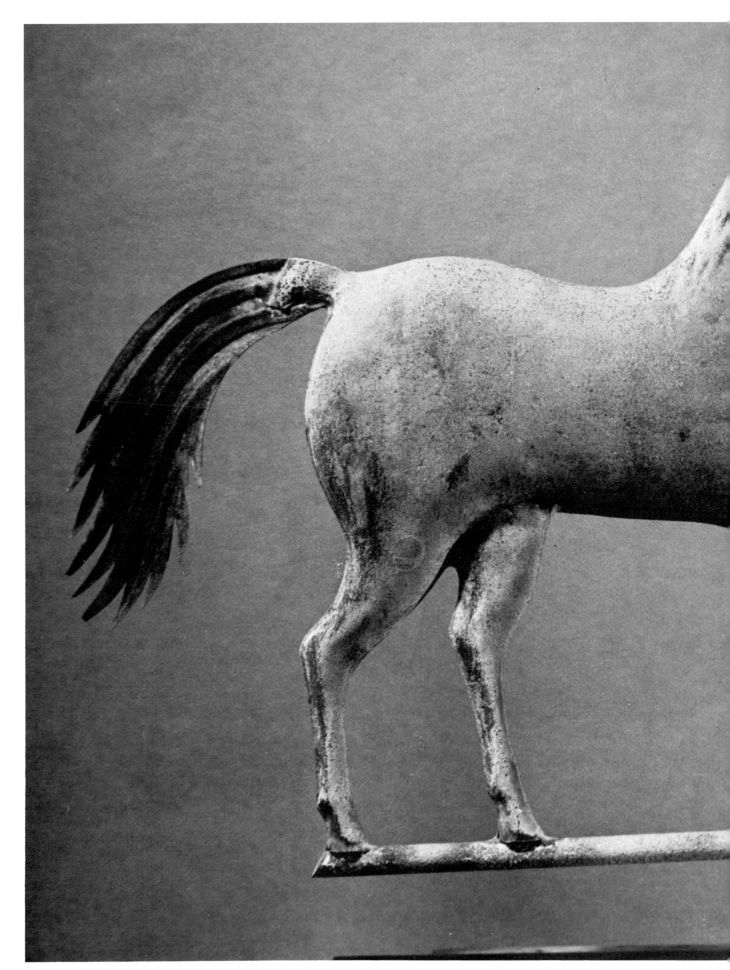

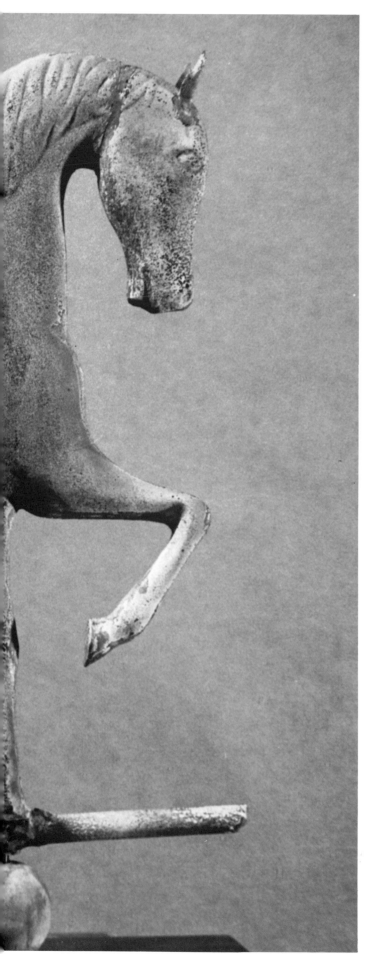

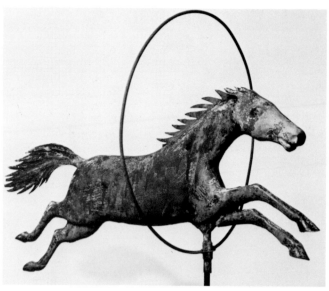

Horse leaping through hoop. A.L. Jewell & Co.:
Private Collection.

Formal Prancing Horse by A.L. Jewell & Co.:
Collection of Martin & Estelle Shack.

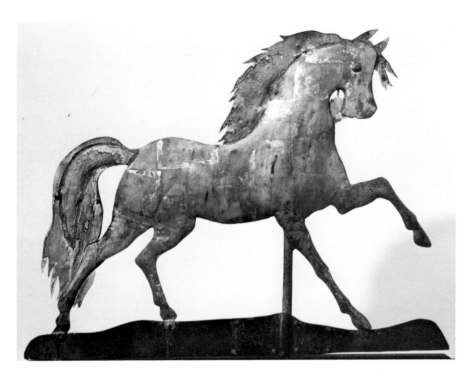

Jewell Prancing Horse. 34" in length: Collection of
Audited Advertising Inc.

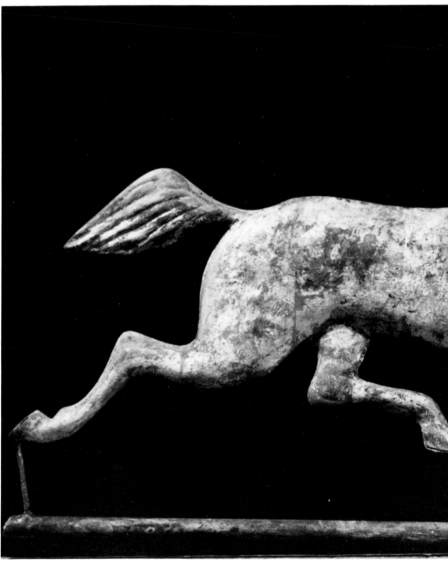

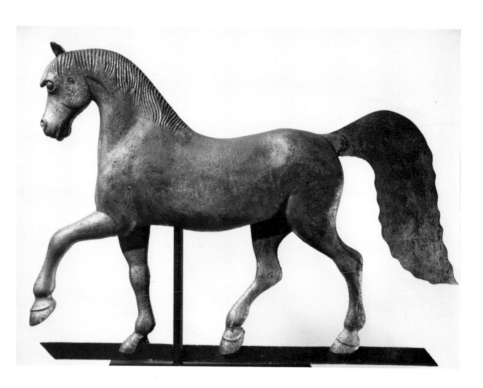

Cast Iron Formal Horse by Rochester Iron Works.
38" in length: Private Collection.

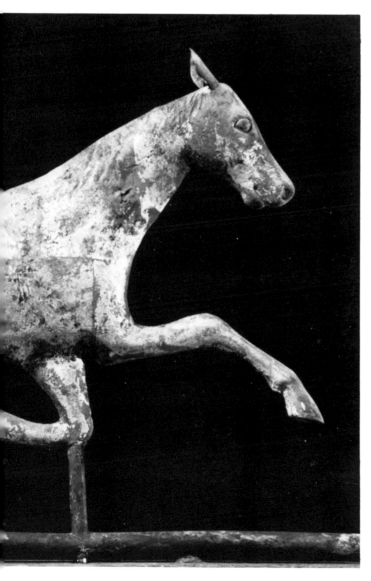

Ethan Allen with Hackney tail. A.L. Jewell & Co.:
Private Collection.

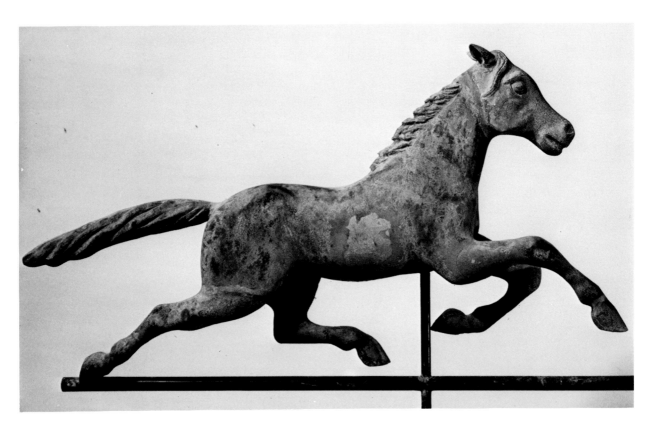

Running Horse by unknown maker. 34" in length;
private Collection.

Standing Horse. 28" in length: Private Collection.

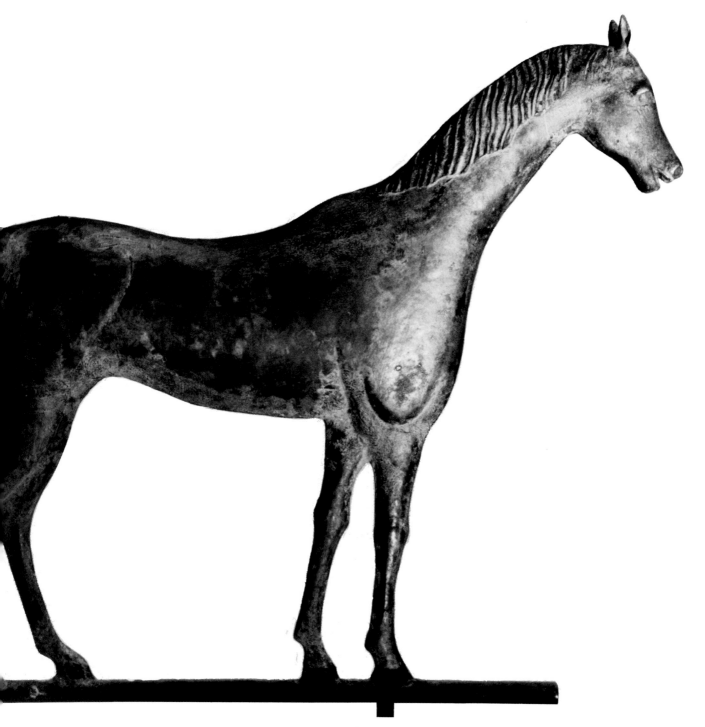

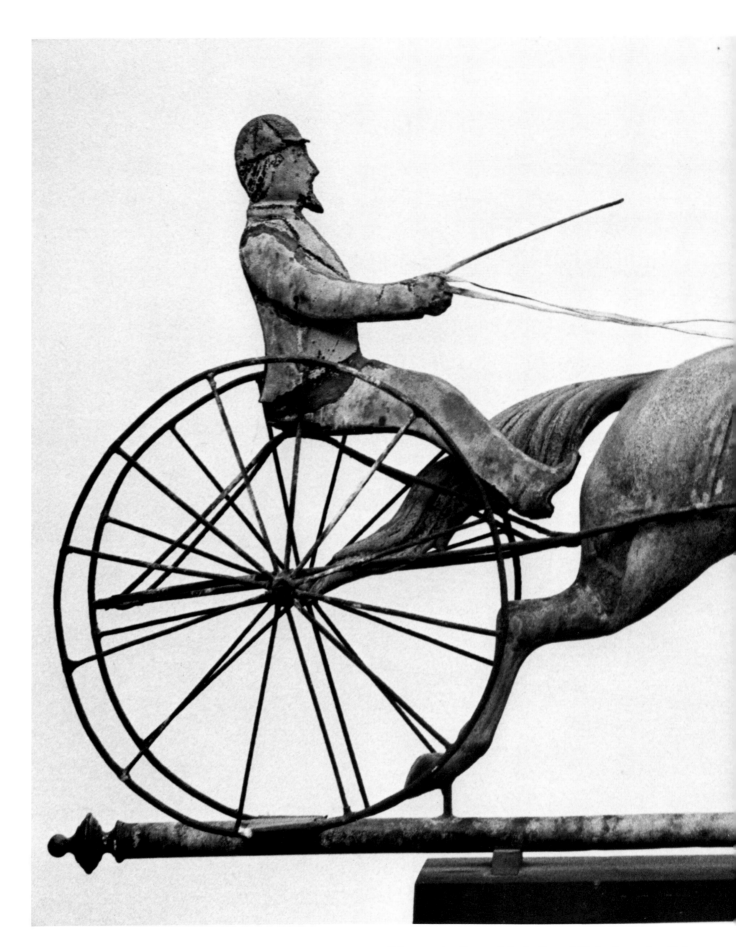

Mountain Boy with Sulky. 38" in length: Private
Collection.

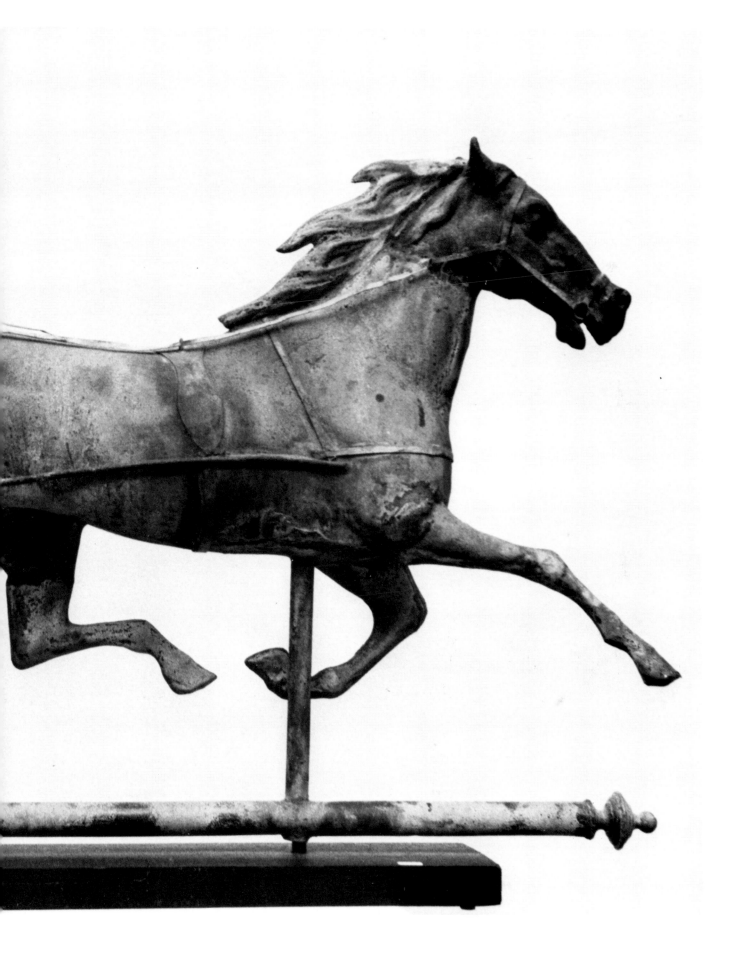

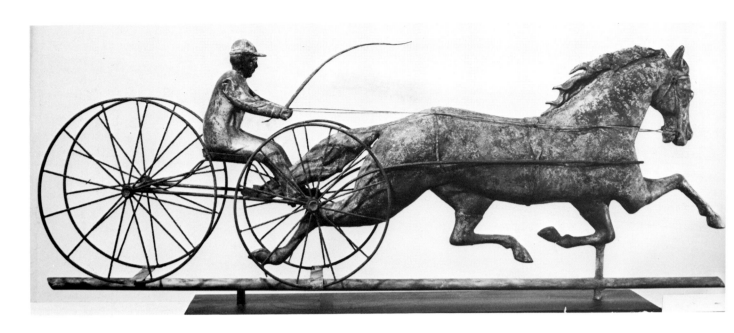

4 Wheel Sulky 62" in length — Copper & Iron, by
J.L. Mott, New York: Steve Miller.

St. Julien with Sulky. 38" in length. Made by J.W.
Fiske, New York, 1887: Private Collection.

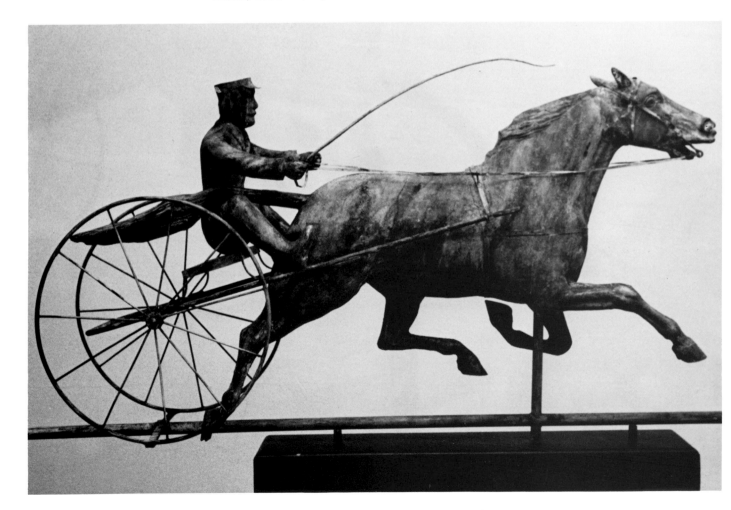

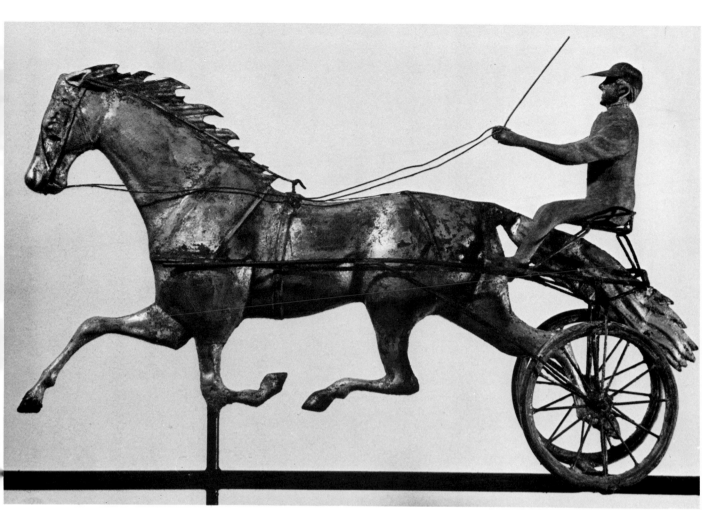

Pneumatic Wheel Sulky, circa 1898: Private
Collection.

Four Wheel Wagon to Team. By J.W. Fiske.
Circa 1880, 60" in length: Private Collection.

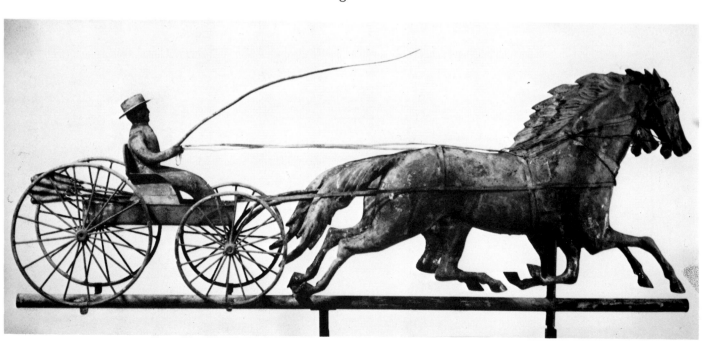

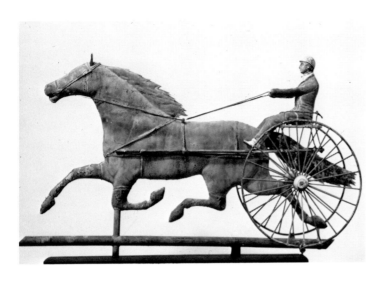

Sulky by Harris & Co., 1885: Private Collection.

Maud S with Sulky, 1887: Private Collection.

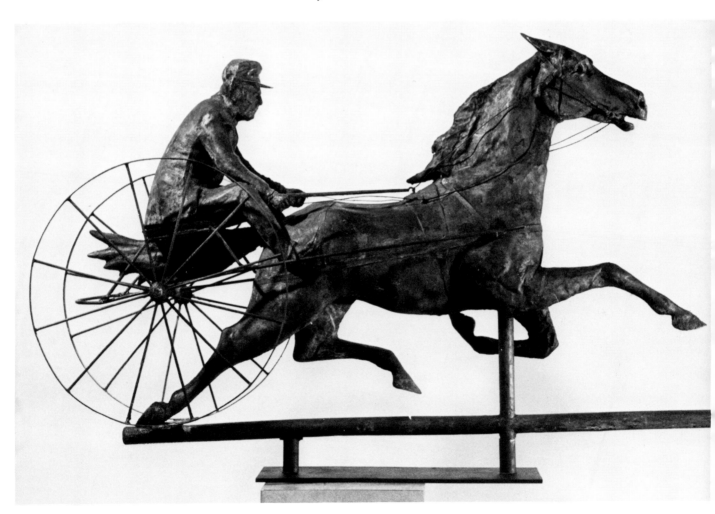

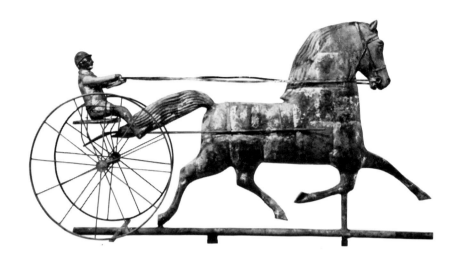

Black Hawk to Sulky: Private Collection.

Mountain Boy to Sulky: Private Collection.

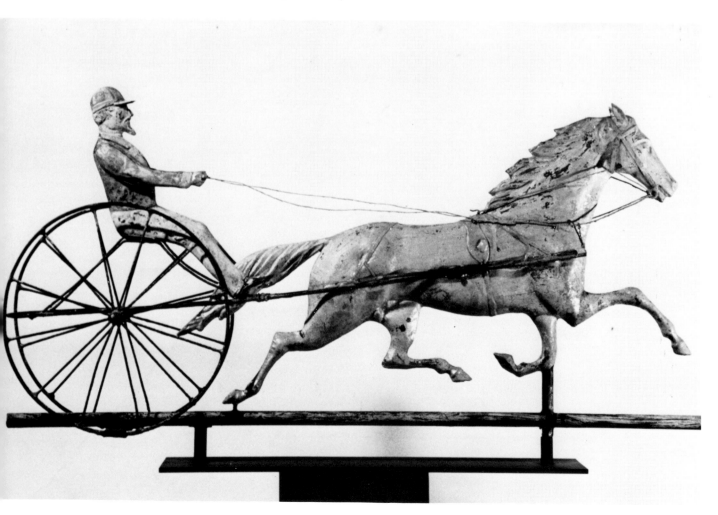

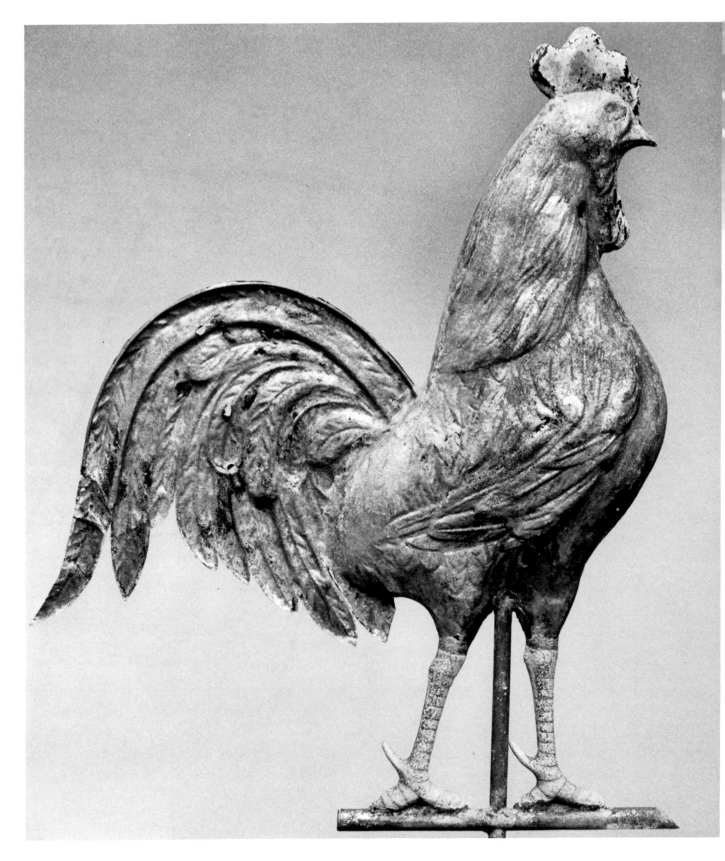

Rooster Vane by L.W. Cushing & Son: Private
Collection.

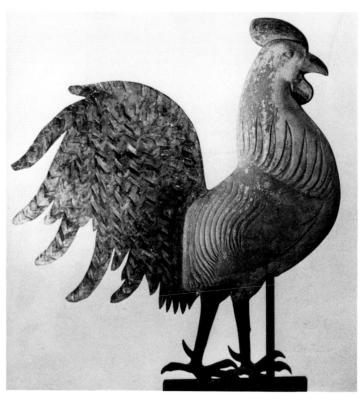

Large Rooster by J. Howard & Co.: Private Collection.

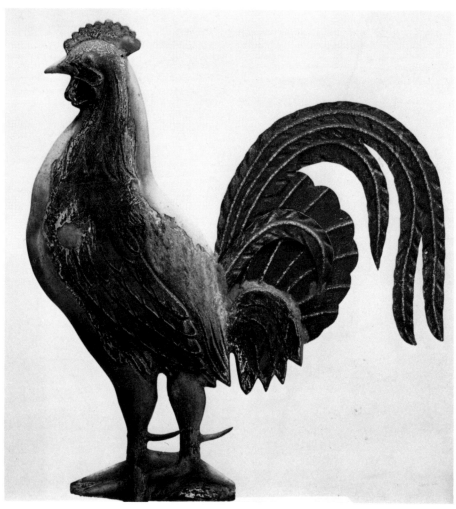

Rooster by A.L. Jewell & Co.: Private Collection.

37

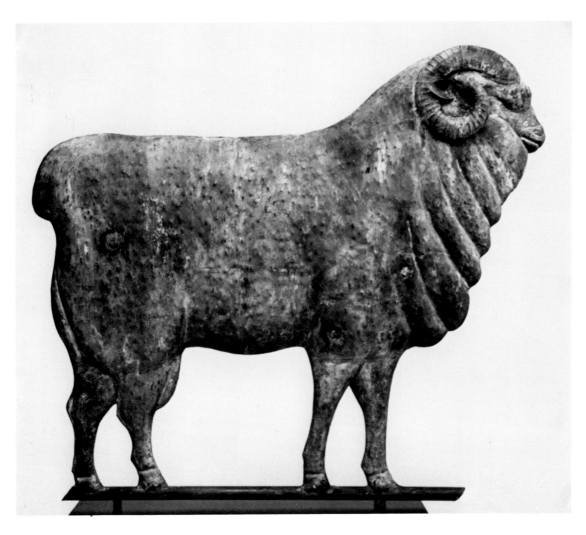

Ram by L.W. Cushing & Co., 36", circa 1880:
Private Collection.

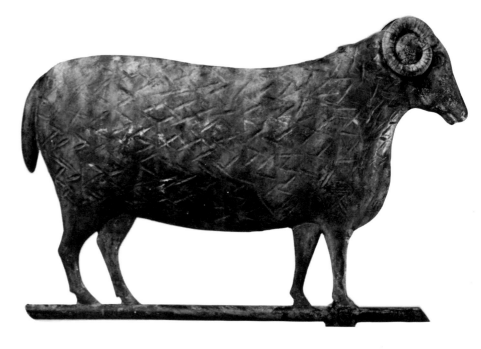

Ram by unknown maker, 34": Private Collection.

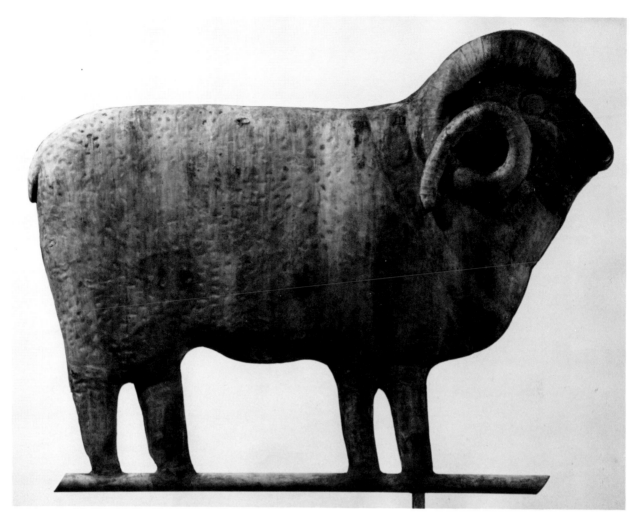

Ram weathervane by Harris: Private Collection.

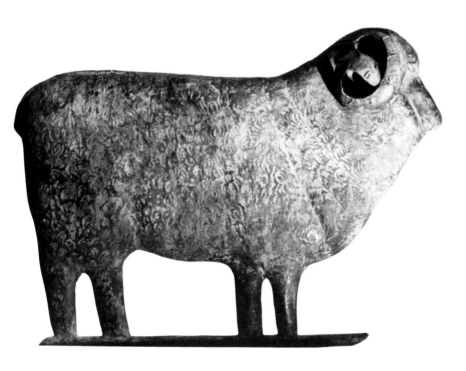

Ram by L.W. Cushing & Son: Private Collection.

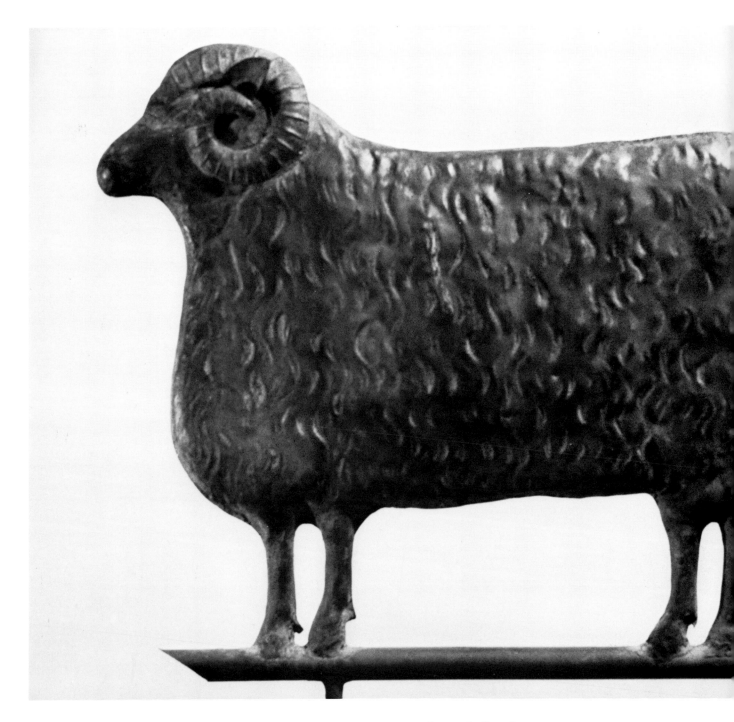

Ram by unknown maker, 28": Private Collection.

Pig by L.W. Cushing, 36": Steve Miller Photograph.

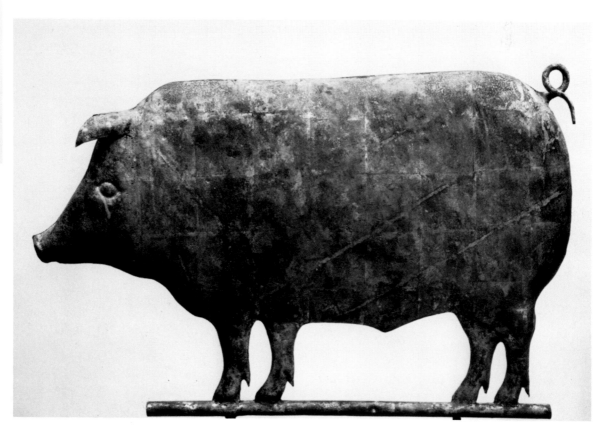

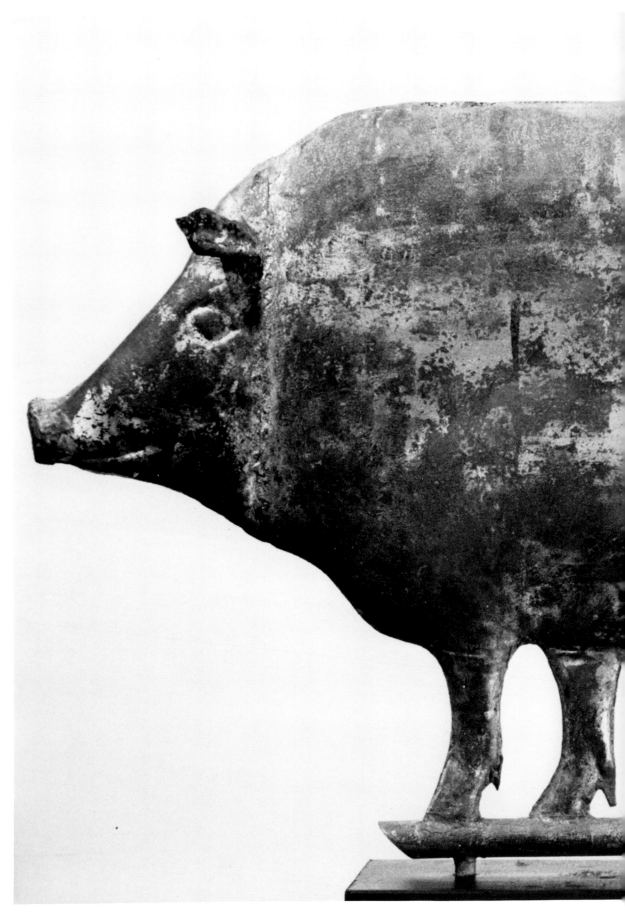

Pig by Cushing & White, 18": Private Collection.

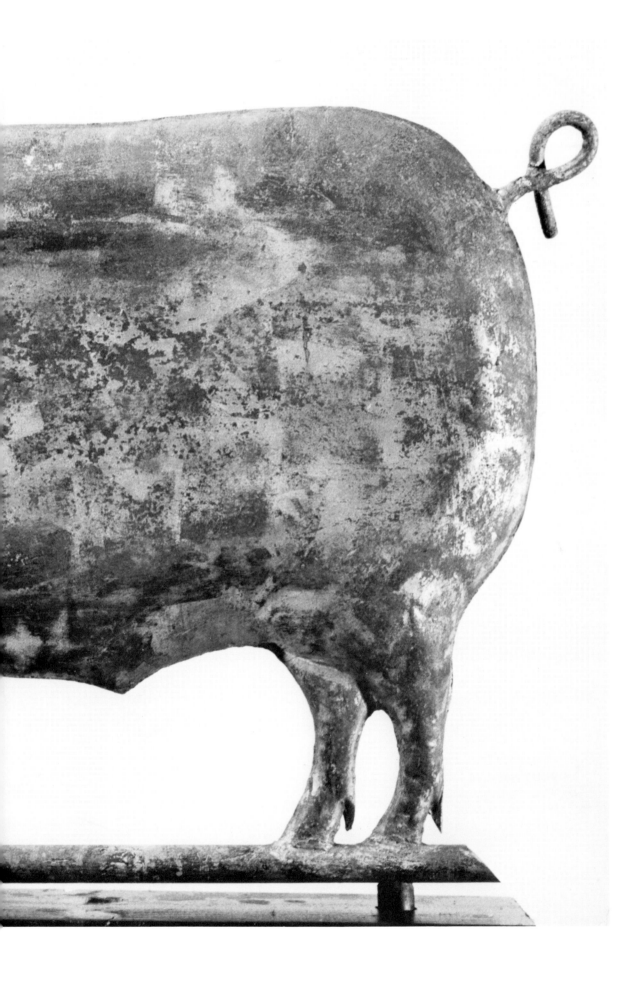

Hog by unknown maker, 36": Collection Audited Advertising.

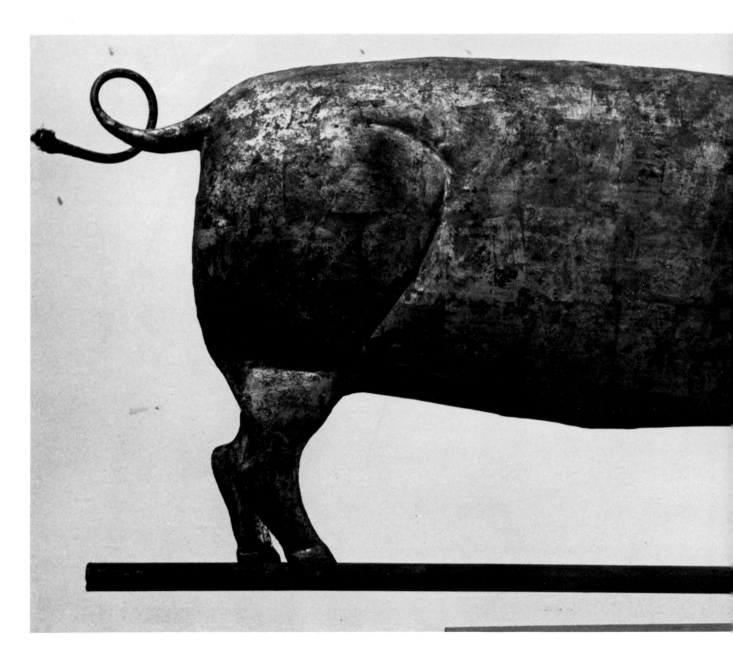

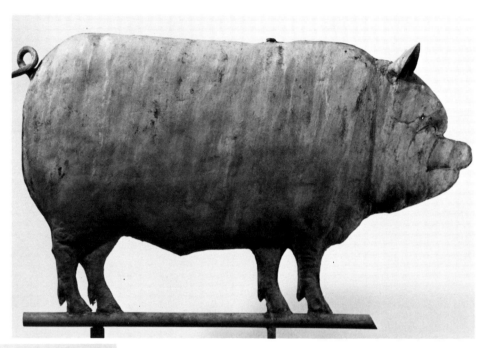

Pig by unknown maker, 36": Collection Audited
Advertising.

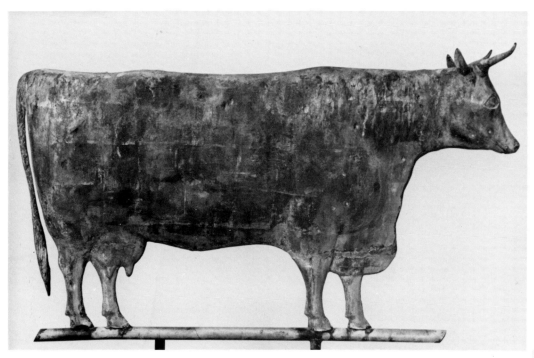

Cow by Cushing & White, 44": Steve Miller
Photograph.

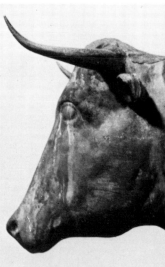

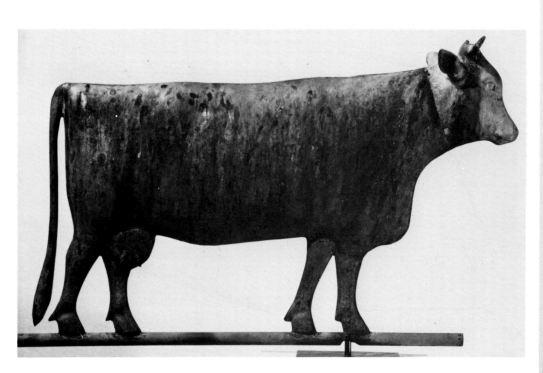

Cow by unknown maker, 24": Private Collection.

Steer by Cushing & White, 38": Private Collec-
tion.

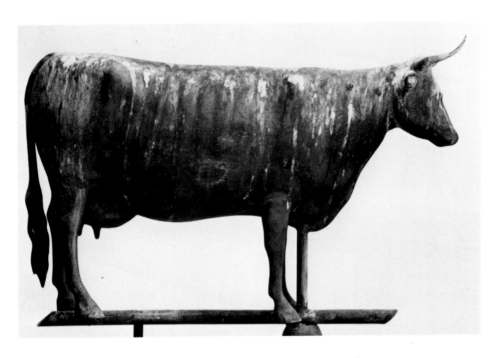

Cow by Harris, 36": Private Collection.

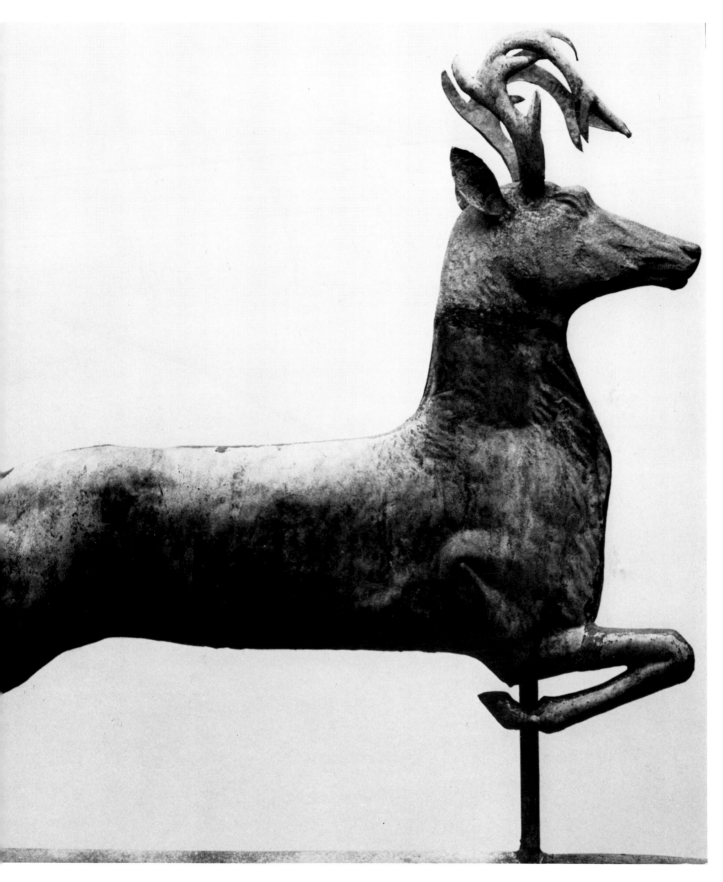

Deer by J.W. Fiske, 32": Private Collection.

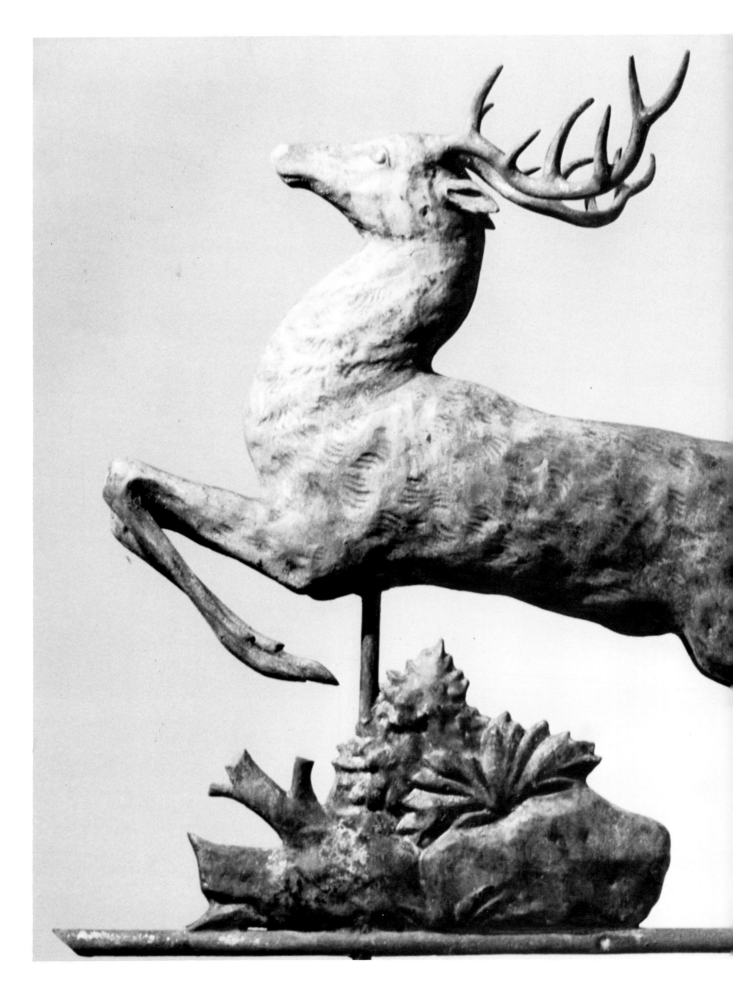

Leaping Stag by Harris & Co.: Private Collection.

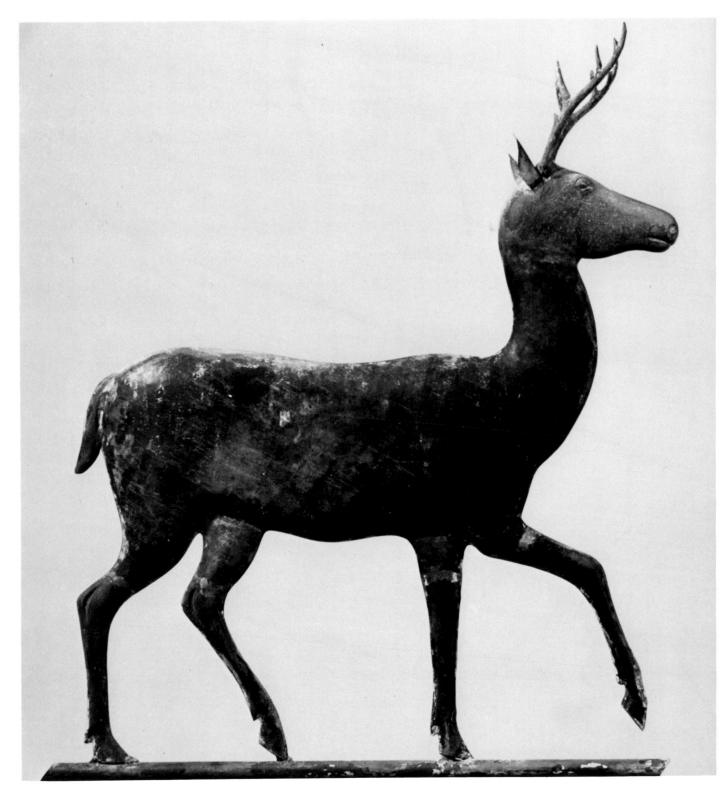

Walking Deer by A.L. Jewell & Co.: Private
Collection.

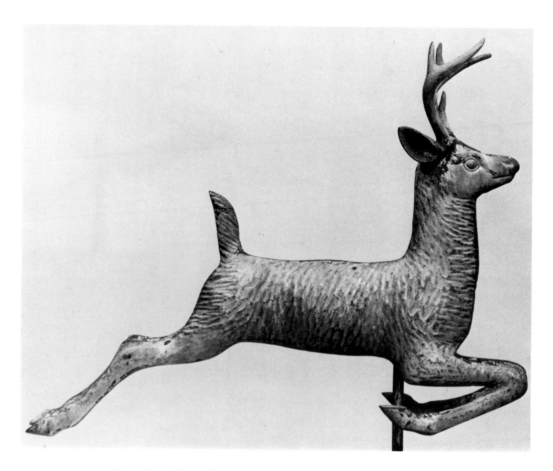

Leaping Deer by Cushing & White, 18": Private
Collection.

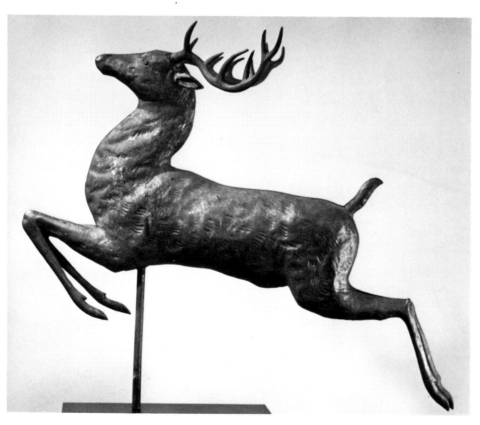

Stag with bush by Harris: Private Collection.

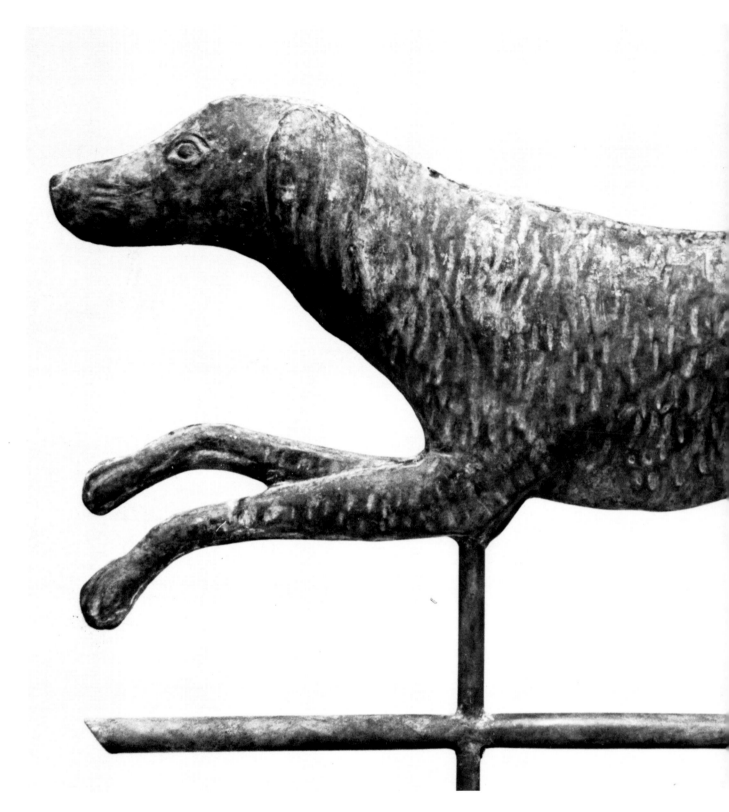

Foxhound by L.W. Cushing, 28": Private Collection.

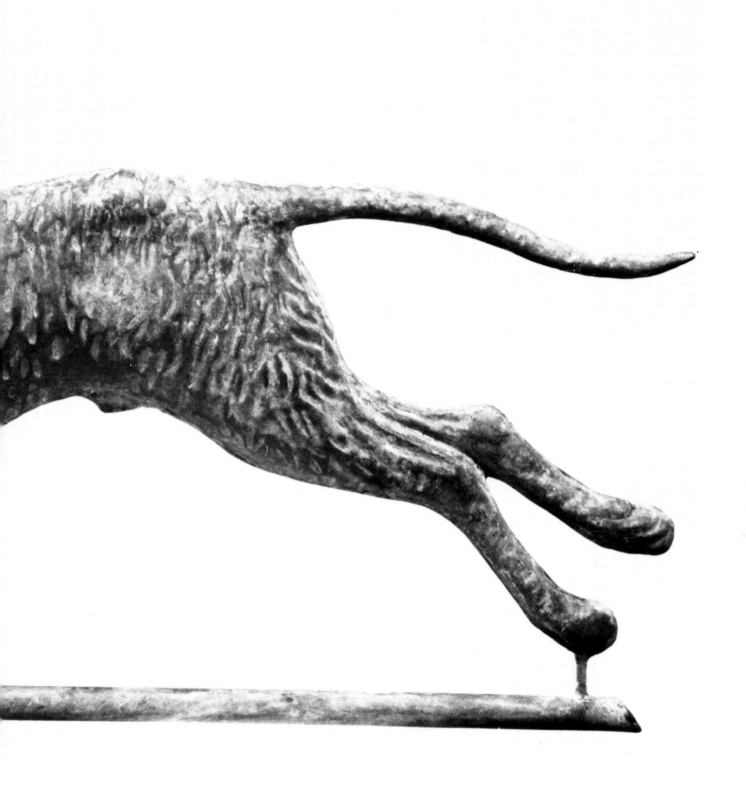

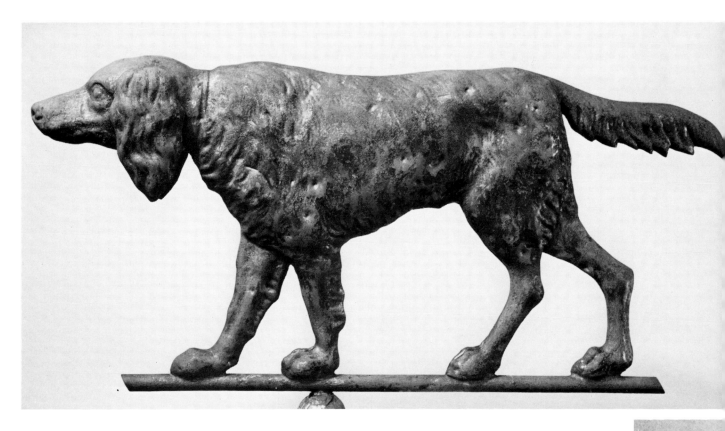

Setter by Washburn, circa 1890: Private Collec-
tion.

Hound and Fox, L.W. Cushing & Co.: Private
Collection.

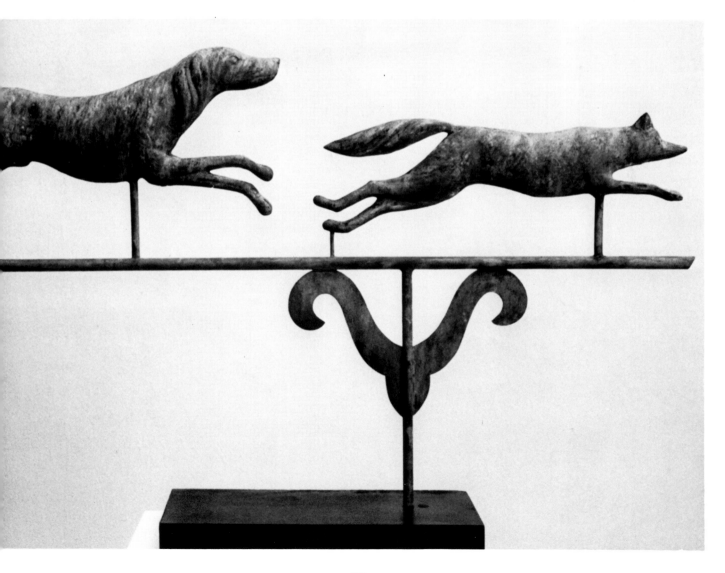

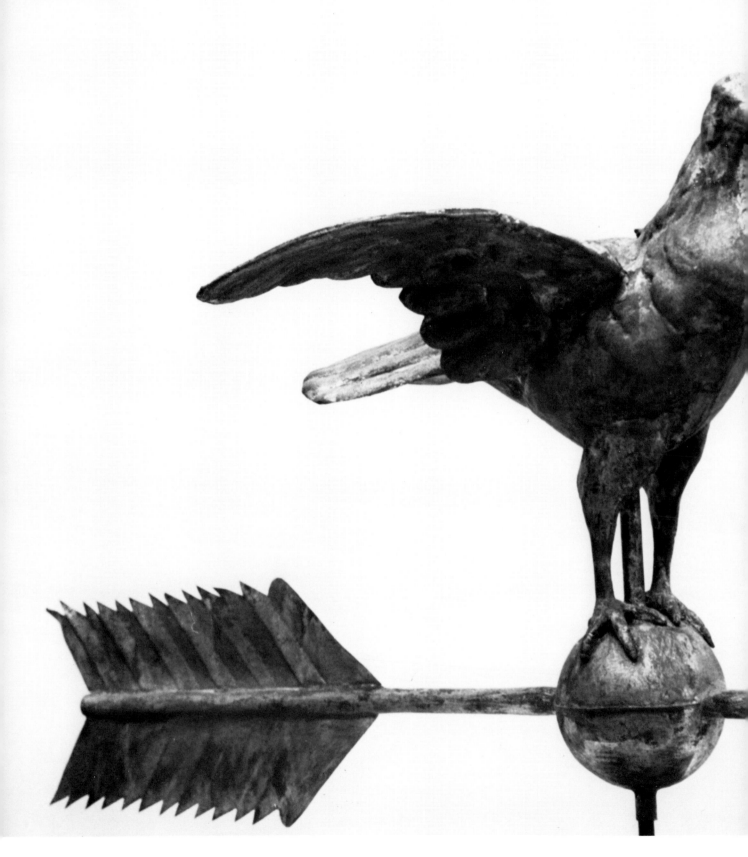

Pigeon weathervane: Steve Miller Photograph.

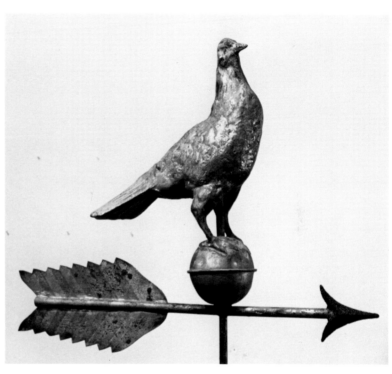

Pigeon weathervane by J.W. Fiske: Private Collection.

Dove weathervane: Private Collection.

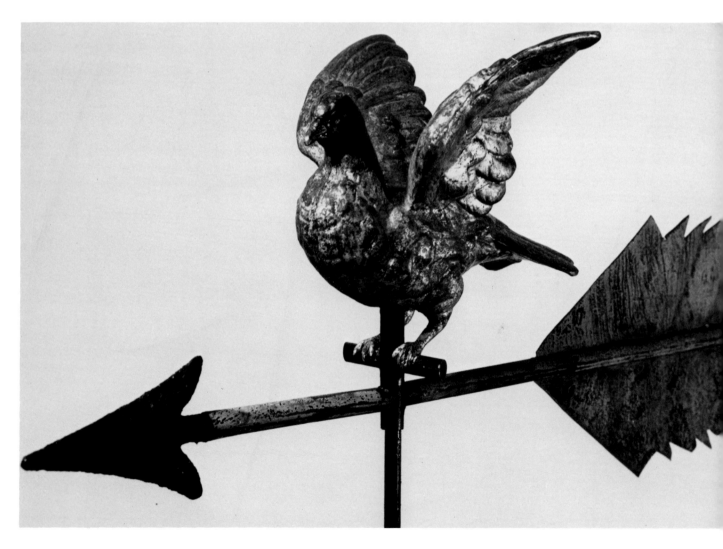

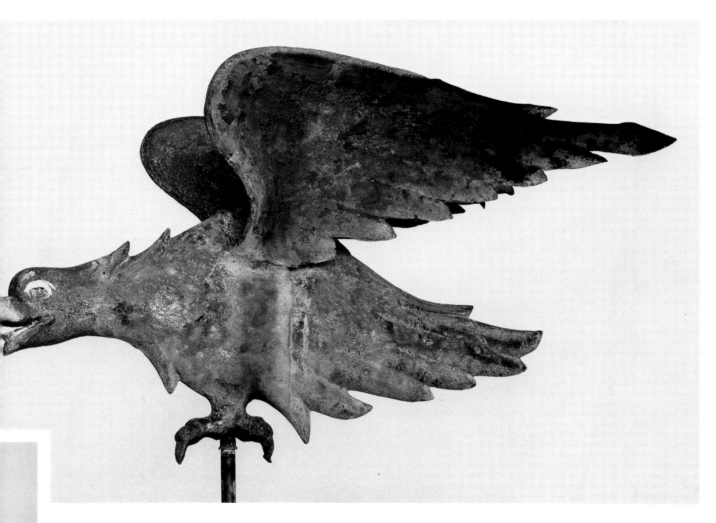

Eagle by A.L. Jewell & Co., Waltham, Massachusetts. Photograph courtesy: Peter Schiffer.

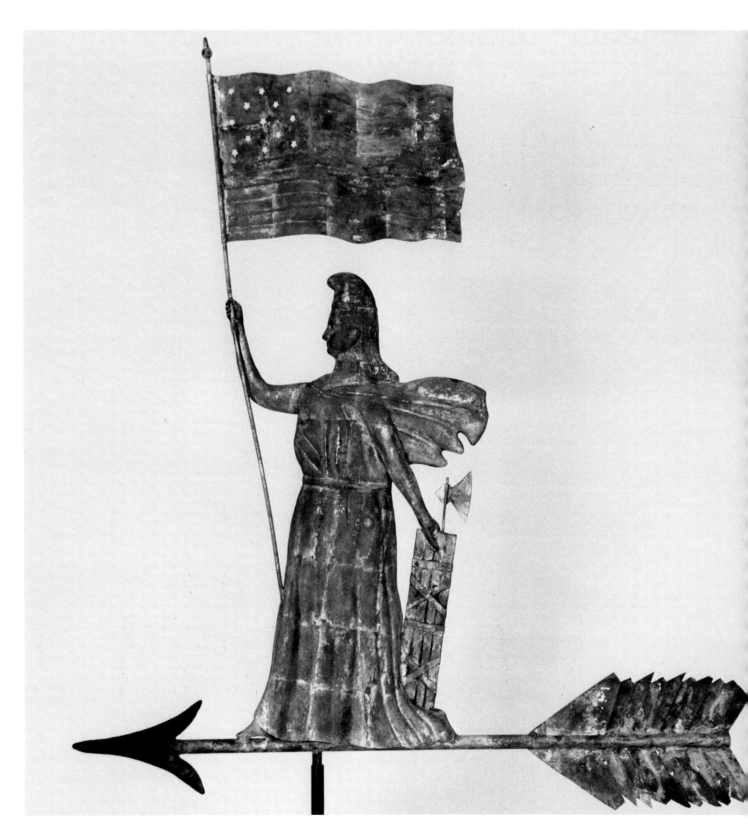

Goddess of Liberty: Private Collection.

Goddess of Liberty by William Henis, Philadelphia: Private Collection.

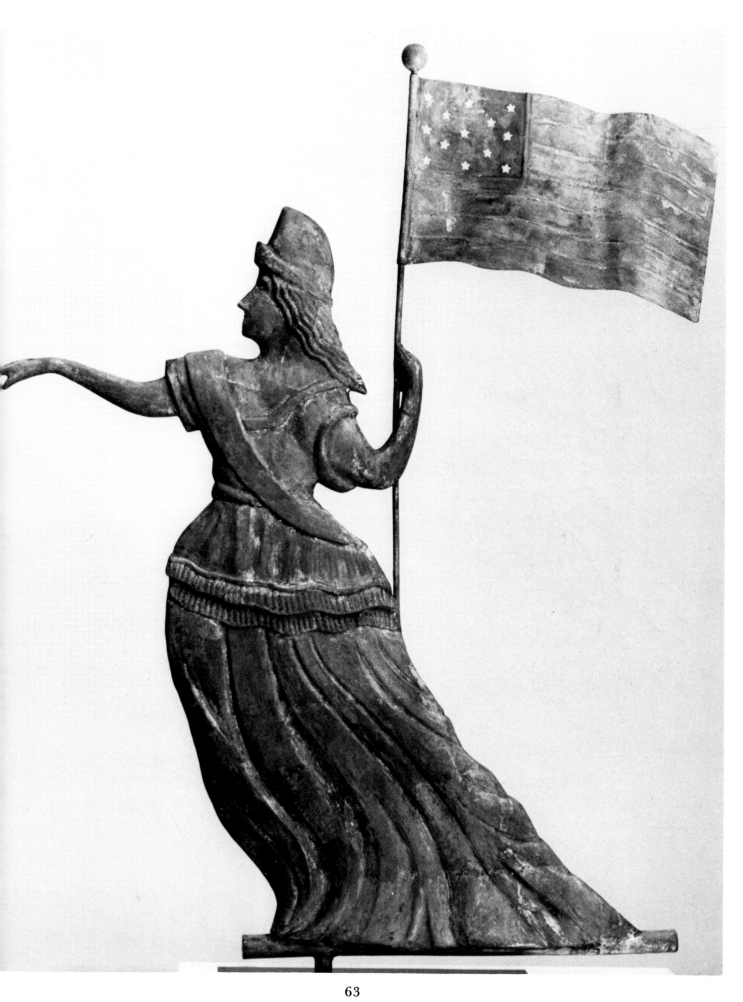

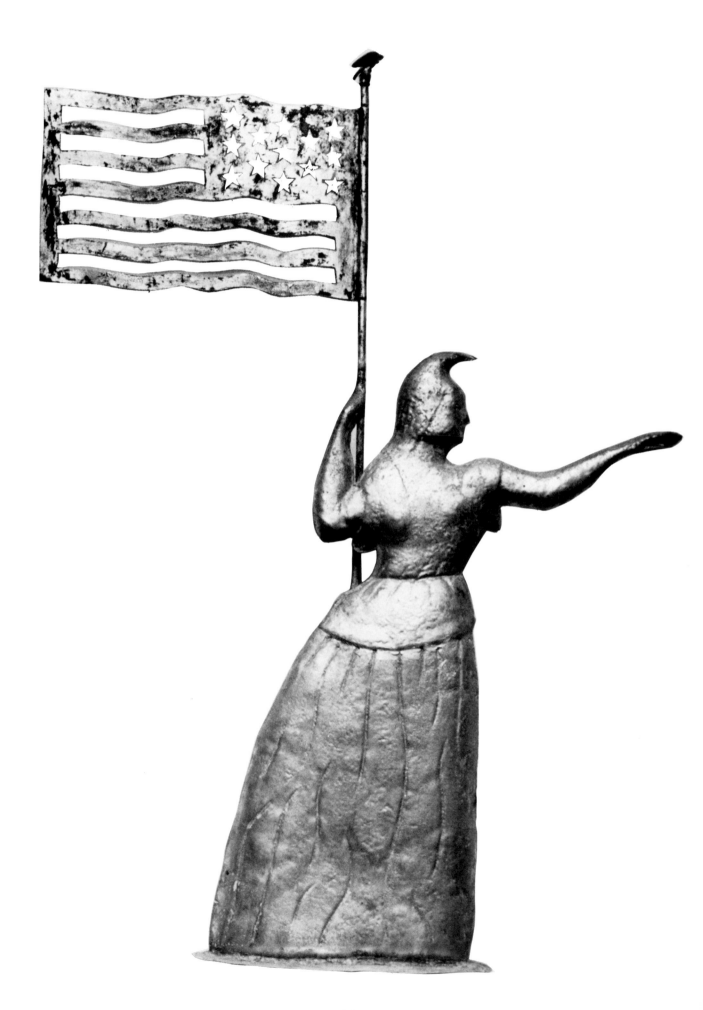

64

Goddess of Liberty by L.W. Cushing: Private
Collection.

Centaur by A.L. Jewell & Co.: Private Collection.

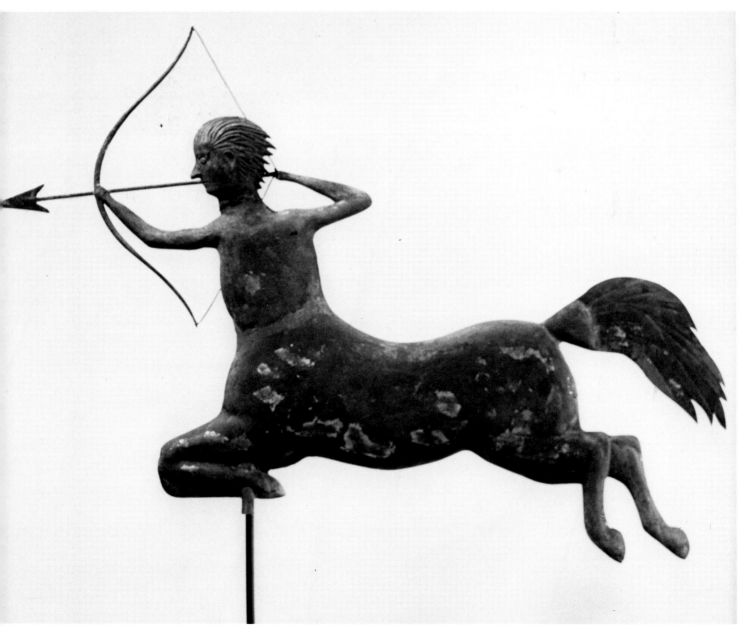

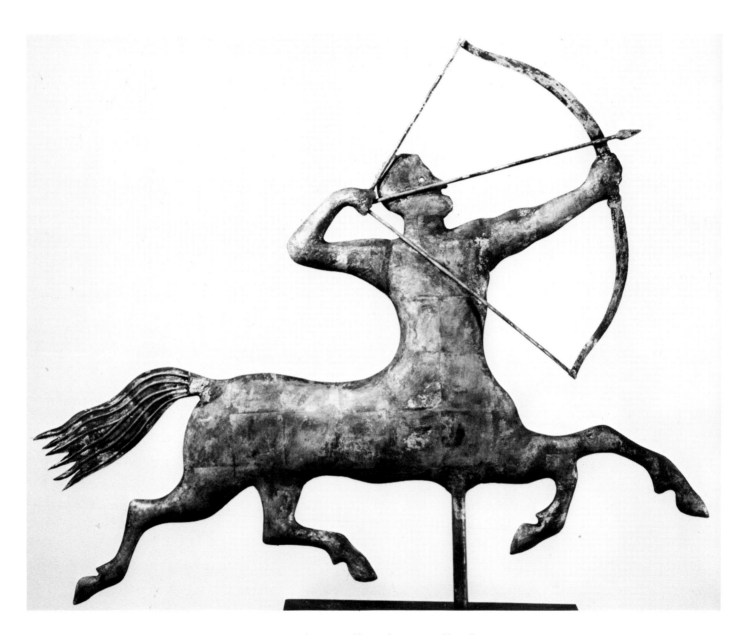

Centaur by Jewell: Private Collection.

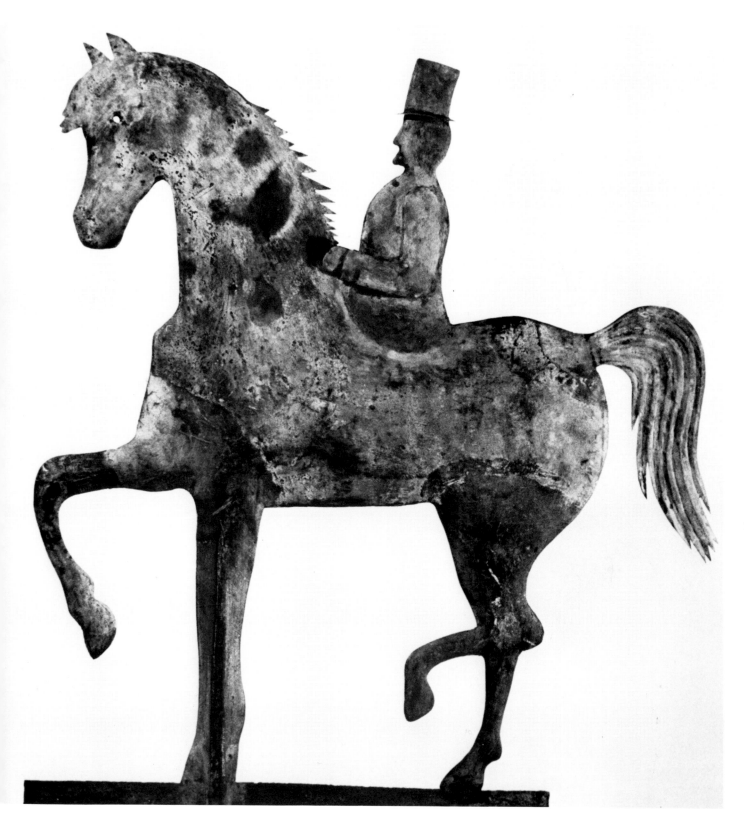

Prancing Horse with Rider by A.L. Jewell: Private
Collection.

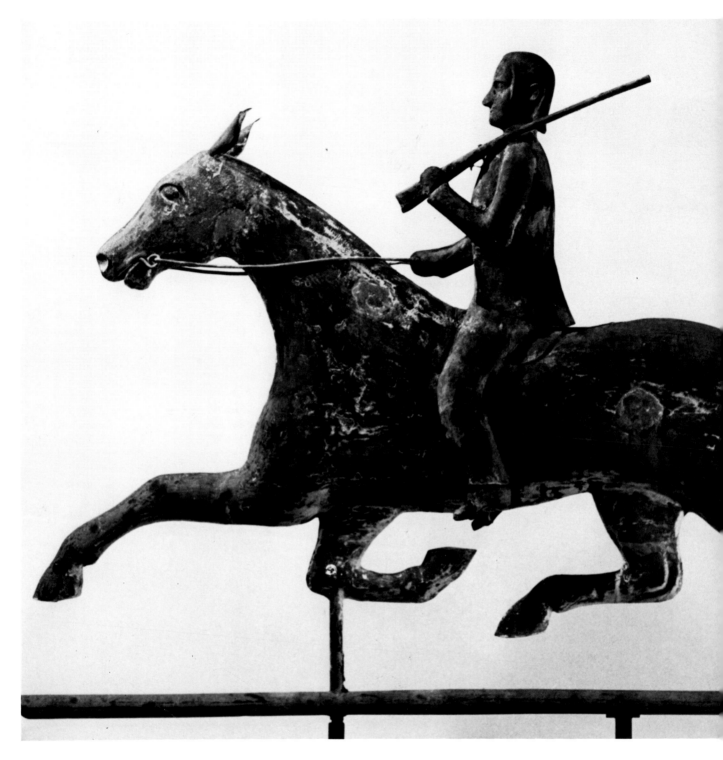

Hunter on Running Jewell Horse, 42": Private
Collection.

Formal Horse and Rider, A.L. Jewell: Private Collection.

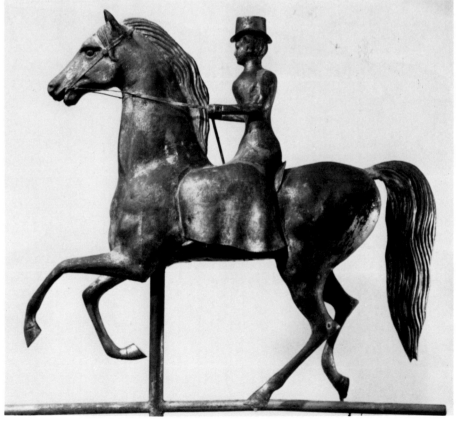

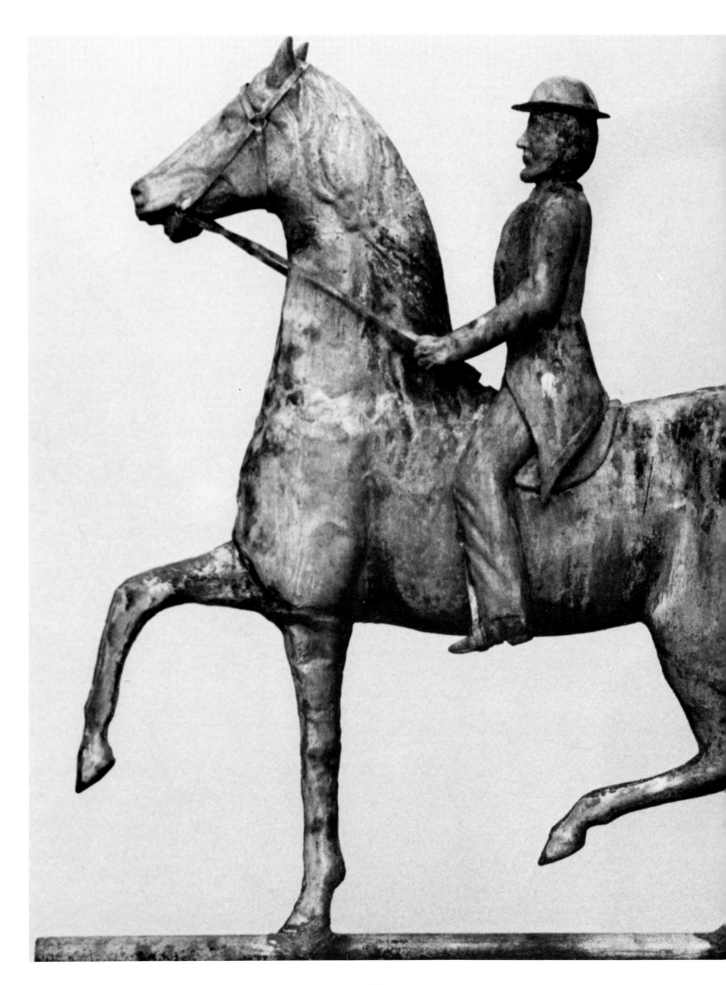

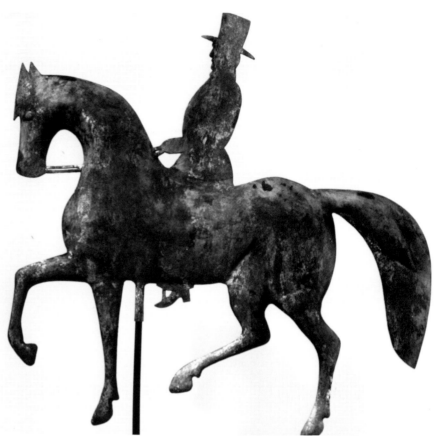

Lady Sidesaddle Rider: Private Collection.

Hambletonian with Gentlemen: Private Collection.

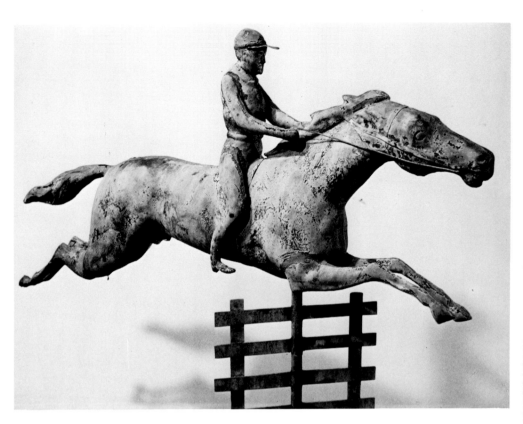

Steeplechase Rider, 32": Private Collection.

Horse and Jockey: Private Collection.

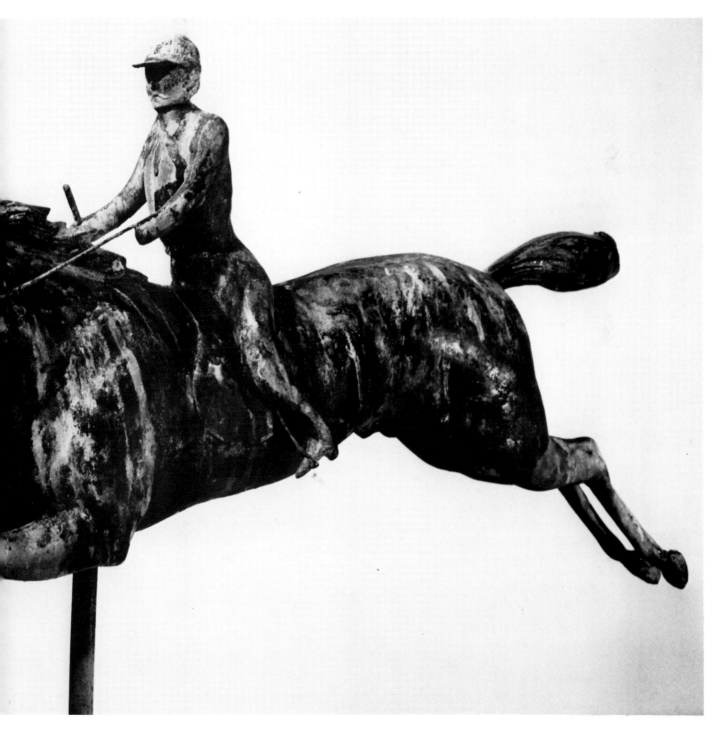

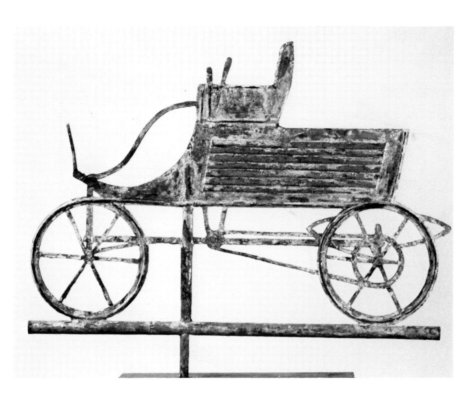

Automobile weathervane, 22": Private Collection.

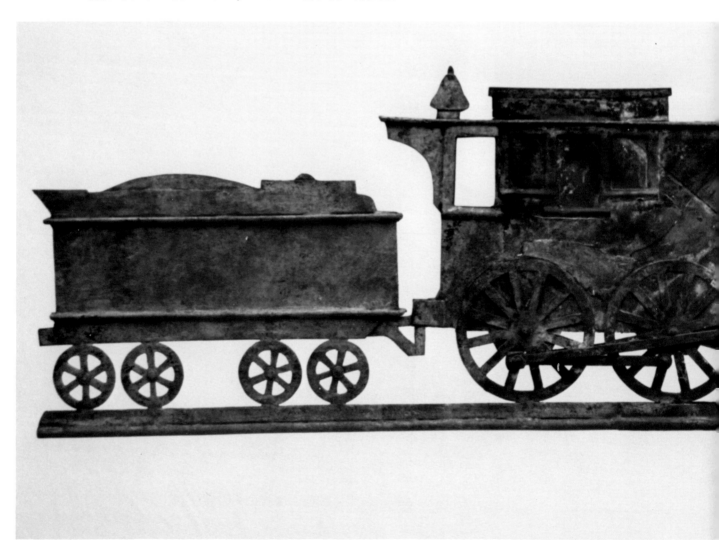

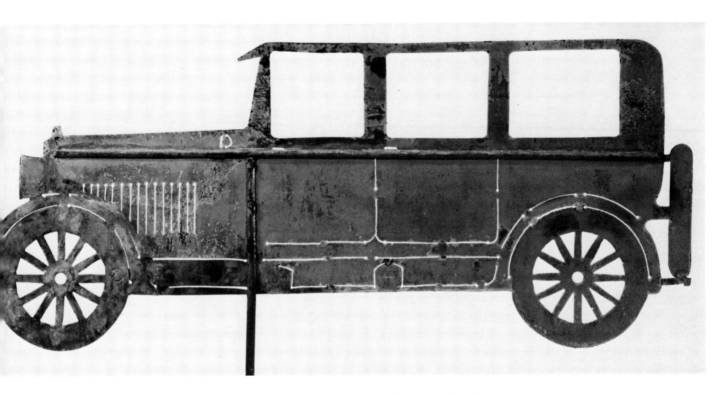

Automobile weathervane, 24": Private Collection.

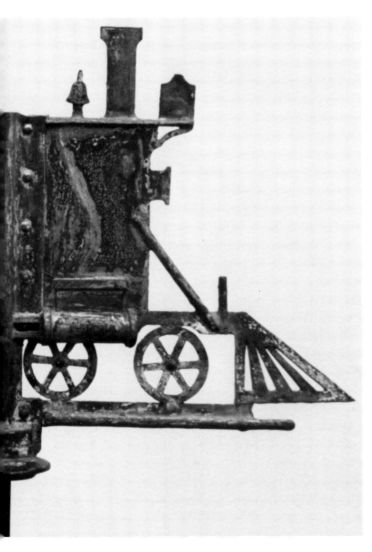

Locomotive and Tender, 32": Private Collection.

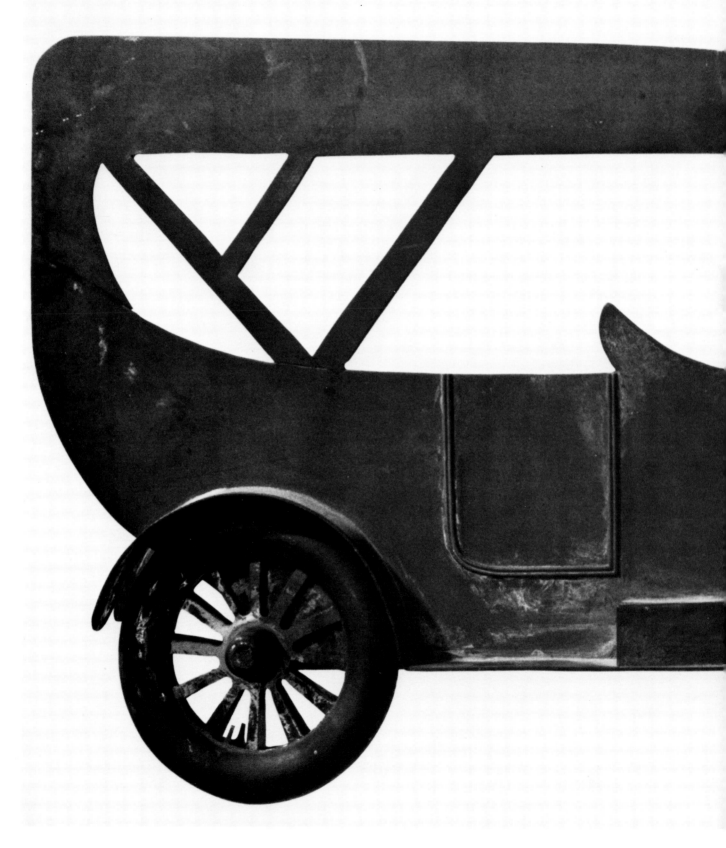

Automobile weathervane, 26'': Collection David
Davies.

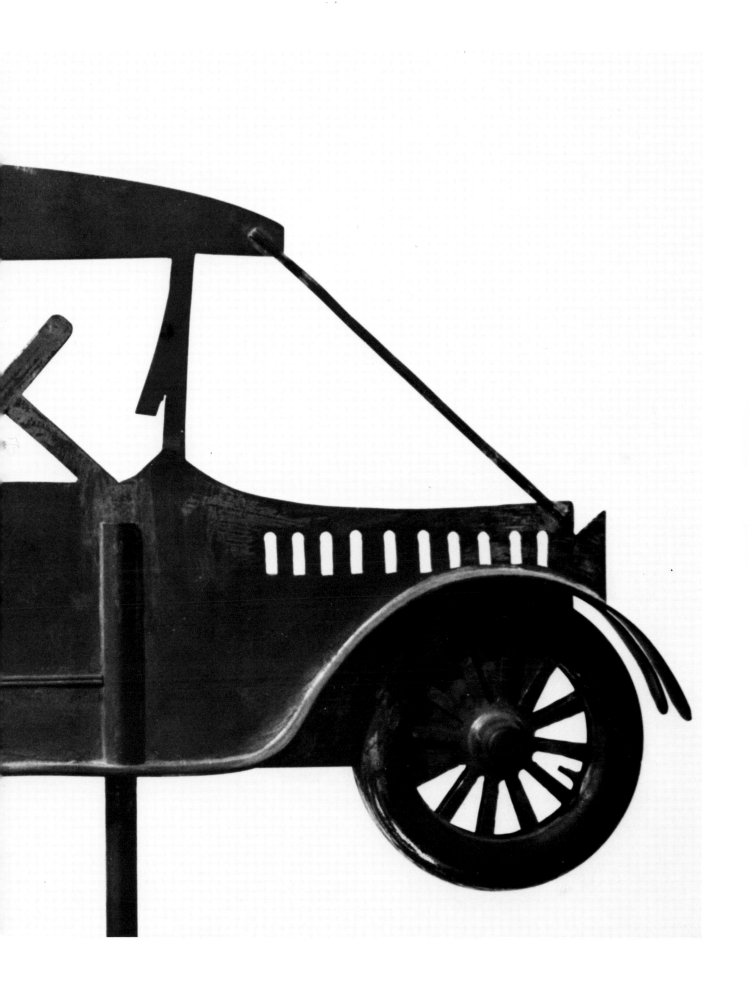

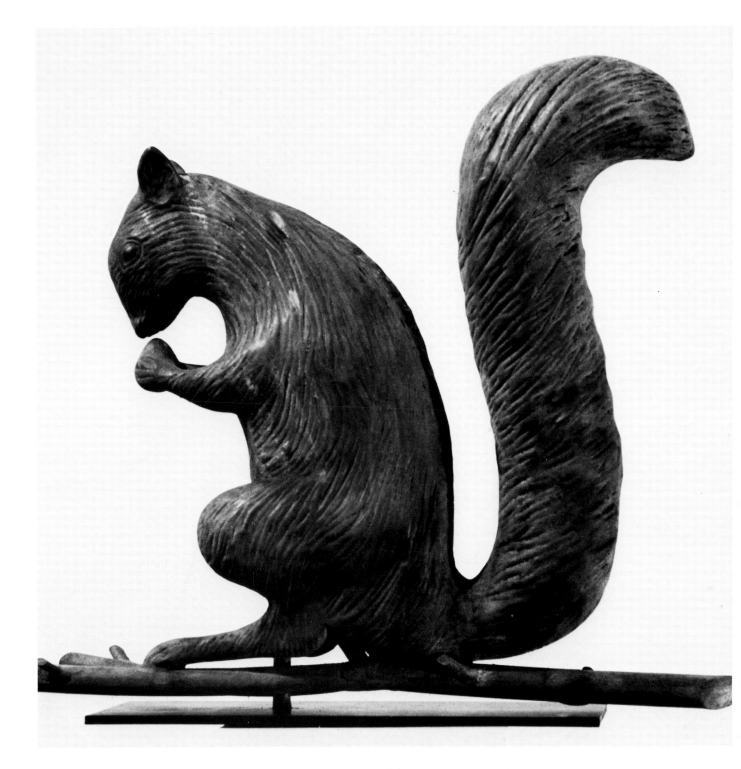

Squirrel by L.W. Cushing & Co.: Marcus
Collection.

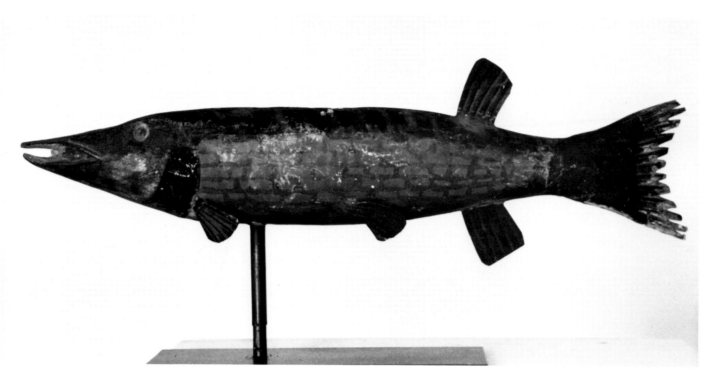

Northern Pike, 24" in length: Private Collection.

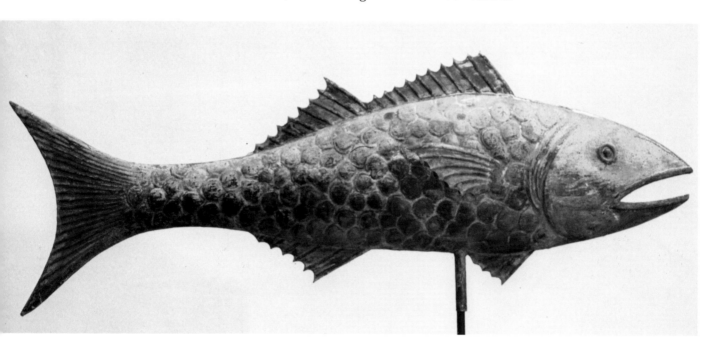

Cod Fish Vane, 38": Collection of Betty and Bob Marcus.

Plow by J. Howard & Co., 52": Private Collection.

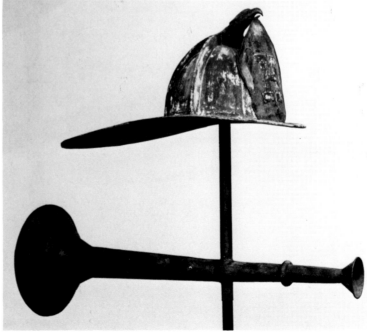

Fire Hat and Trumpet: Private Collection.

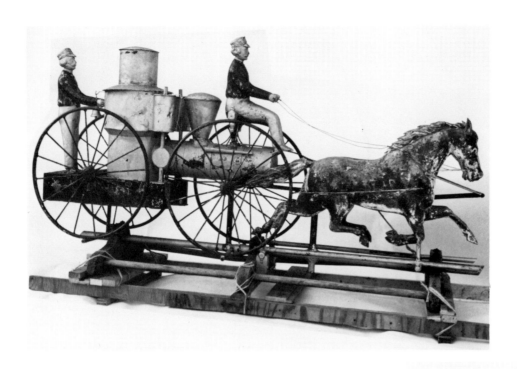

Hose Cart, probably by Harris & Co., Boston, Massachusetts. Photograph courtesy: Peter Schiffer.

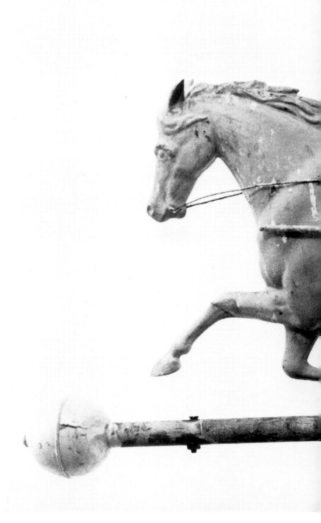

Fire Pumper by Harris & Co., Boston. From the
fire station in Hallowell, Maine: Sam Pennington
photograph.

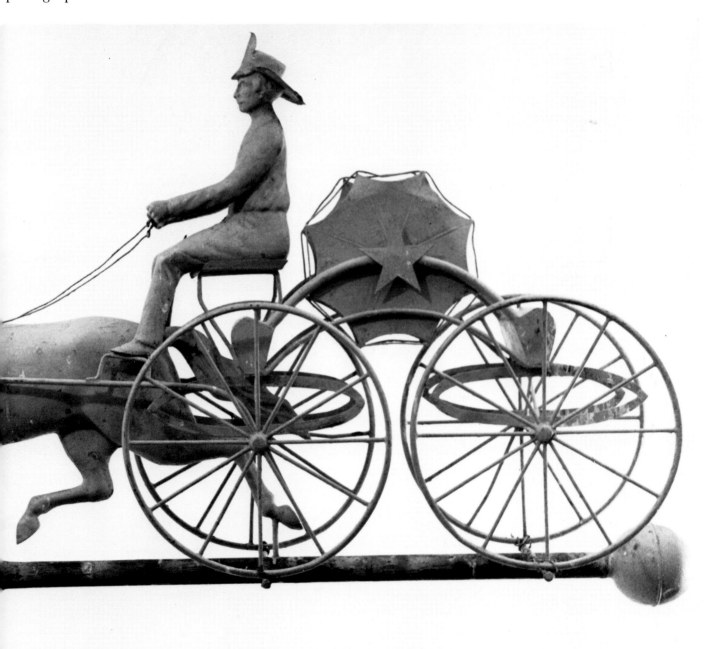

Officer on Horse—Sheet Iron: Ken and Ida Manko.

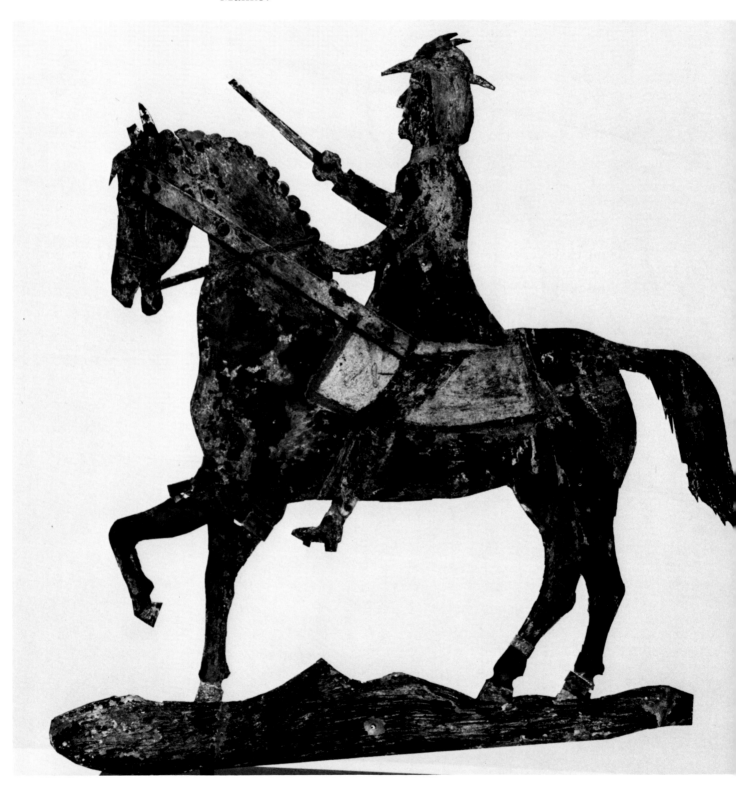

Chapter 2

Individual Efforts

For many reasons, including economic ones, individual craftsmen and artists often chose to make weathervanes of their own design. These often equaled and sometimes surpassed the beauty of the store bought examples. It is unfortunate that in most cases very little is known about either the origin or the artist responsible for the weathervane.

Often the artist would copy the design of a factory-made weathervane, with varying degrees of success. Since the weathervane had to point *into* the wind, the center of balance had to be placed closer to the front or head of the weathervane; and it would often help if the front part was heavier than the rear. A general rule was to place the point where the spindle entered the weathervane at a point roughly 1/3 of the length of the entire vane. It is obvious that if the spindle entered in the center of the weathervane it could not be trusted to turn in any specific direction.

Most of these individual efforts were made of sheet iron or a plank of wood, and often had applied strapping applied to reinforce the strength of the entire piece. For finishing, the piece was usually painted; but on occasion we find an example that has been gilded with real gold leaf.

One of the major problems in collecting of these individually-made weathervanes is that in the absence of actual, documented provenance, it is very difficult to accurately date most examples. Unpainted sheet iron will rust quickly when exposed to the elements; and this process can be hastened through applications of various acids. By the same token, a weathervane made of wood will also age heavily when exposed to the elements and left unfinished or unpainted, and a coat of paint will be almost completely worn away within thirty years. It is far more important to examine the edges of the weathervanes, whether steel or wood, than to be influenced only by the painted side surfaces. A careful examination of the *cut* edge of the sheet iron with a 8x glass should show pitting rather than a clean cut edge. Rivets, if made of steel or iron, should be rusted into almost one piece with the rest of the sheet iron, and iron rivets on a copper weathervane should have bled iron oxide onto the copper surface, leaving a red streak over the green patina of the copper. On weathervanes made of wood, check the raw edges carefully; and be sure that the years of weathering have eaten away the softer exposed grain, creating ridges along those edges. It is easy to take an old piece of weathered barn siding and cut out a weathervane; however; most of these efforts are given away by the clean cut raw edges, which should show as much weathering as the sides.

Most of these individually-made weathervanes reflect the character of the farm or area in which they were made. Thus, we find Fish and Sailing Ship weathervanes on Cape Cod; and Horses, Cows, Roosters, and other farm animals in the New England farming areas.

Most New England churches had as weathervanes: Roosters, Banners and occasionally an Angel Gabriel to grace the skies. Most of the Rooster weathervanes found on churches however, reflect a more European design rather than the Classic American Rooster most of us find so appealing.

It should again be remembered, that the type of weathervane: factory made or individually crafted, is far less important than the beauty of the individual form itself. It should be the *art* alone that separates the sculpture from the artifact.

Indian—Sheet Iron: Marty and Estelle Shack.

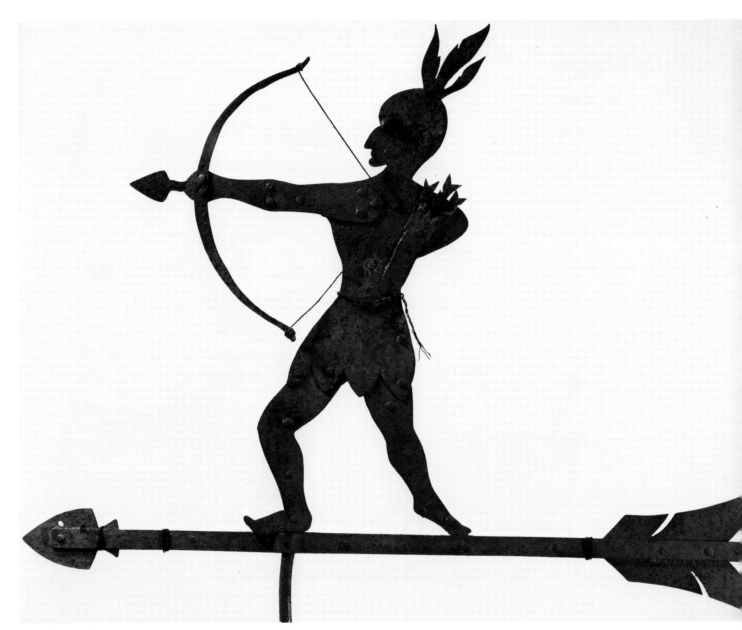

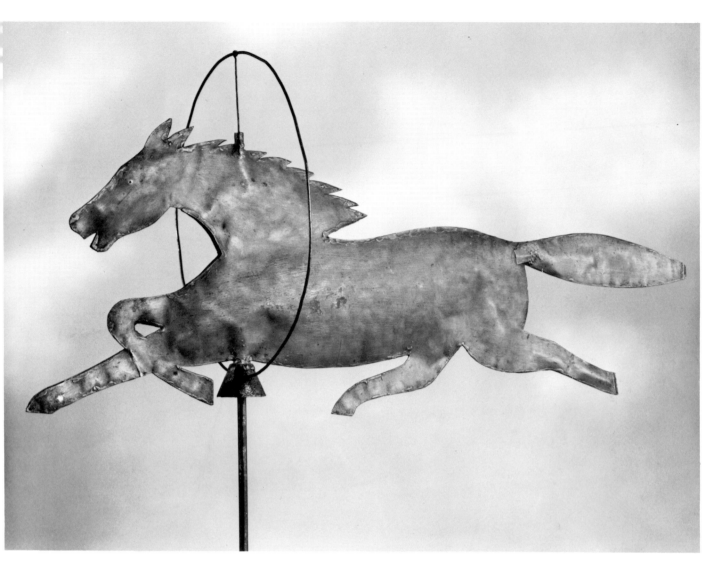

Running Horse with Hoop: Ken and Ida Manko.
Hand of God — Wood: Private Collection.

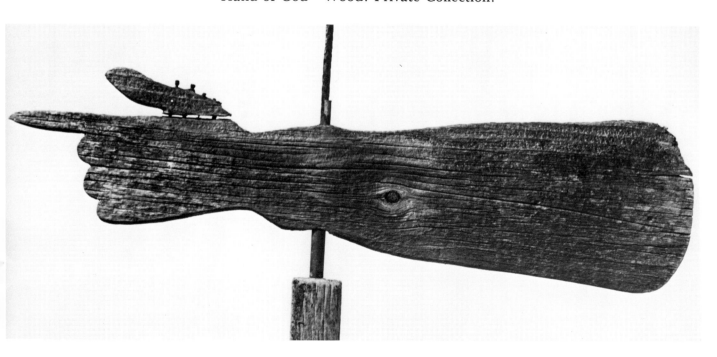

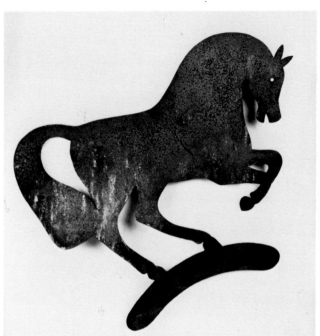

Sheep—Wood with Metal Ears: Private Collection.

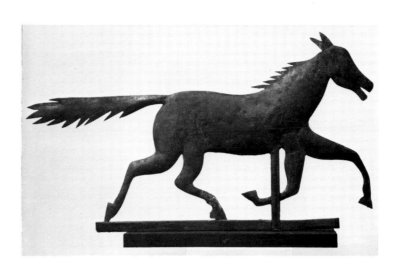

Running Horse—Sheet Metal: Steve Miller.

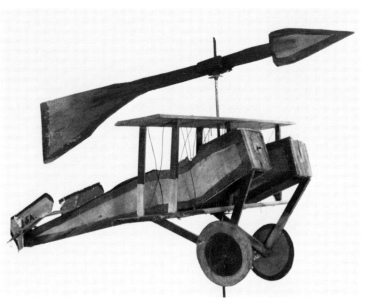

Biplane—Metal and Wood: Samuel Pennington.

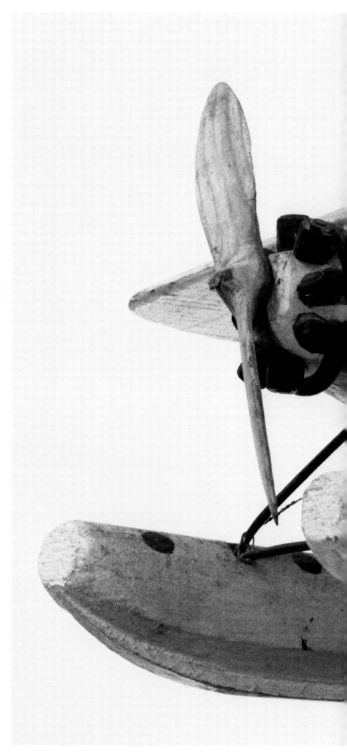

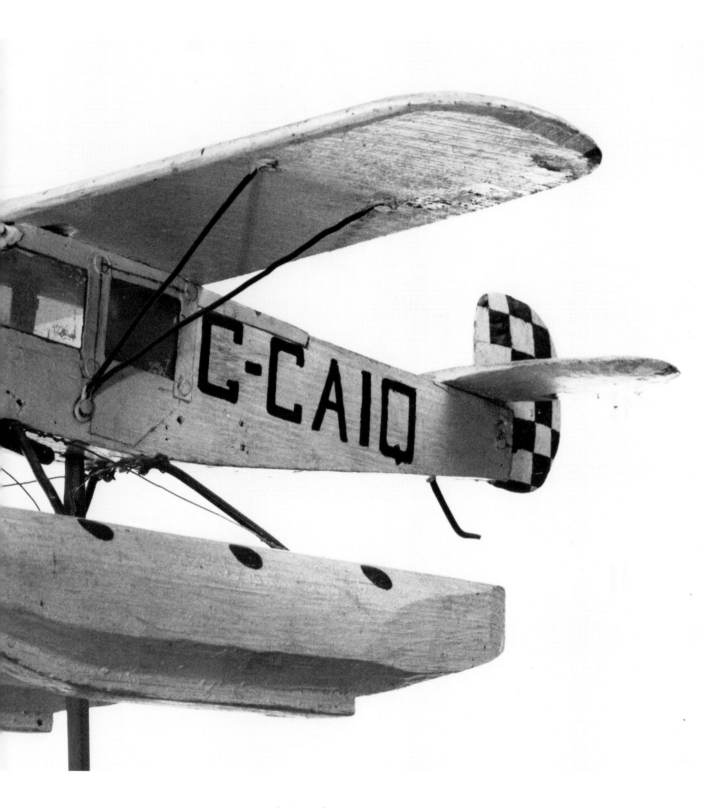

Sea Plane — Wood and Metal: Samuel Pennington.

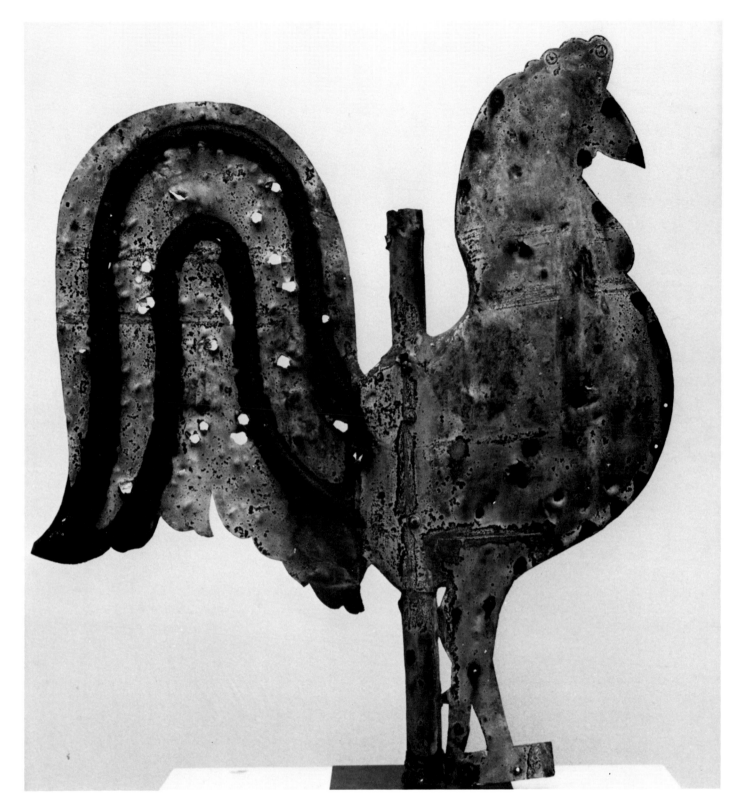

Rooster — Copper and Iron: Ken and Ida Manko.

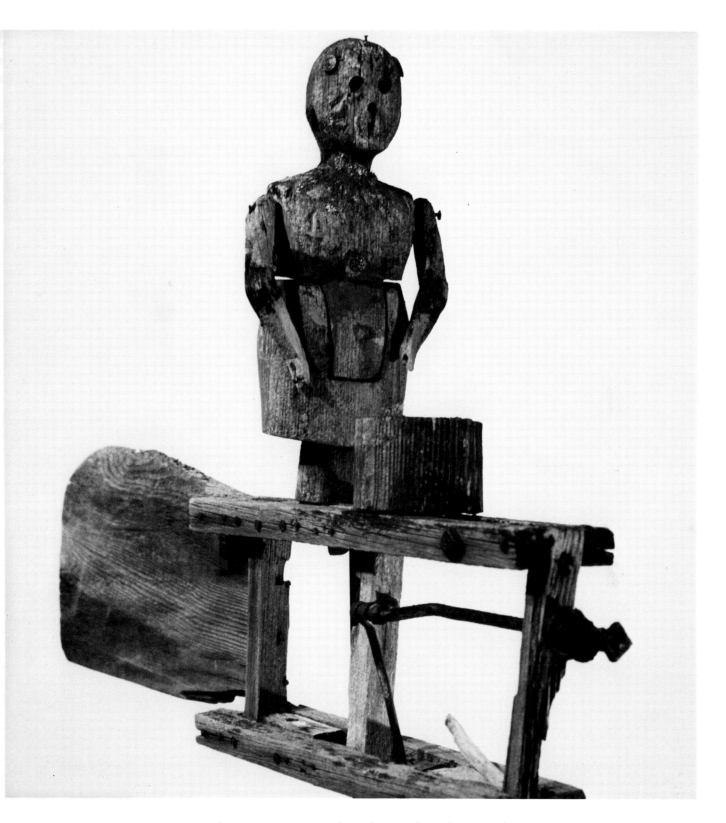

Washerwoman—Wood and Metal: Private Collection.

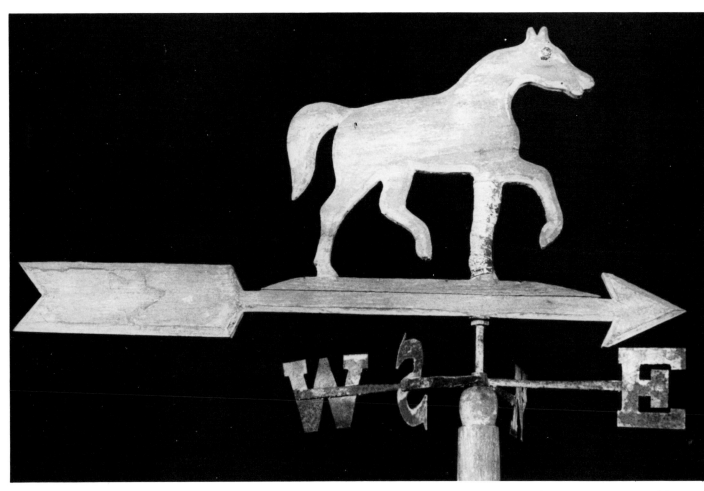

Horse and Arrow—Metal Directionals: Samuel
Pennington.

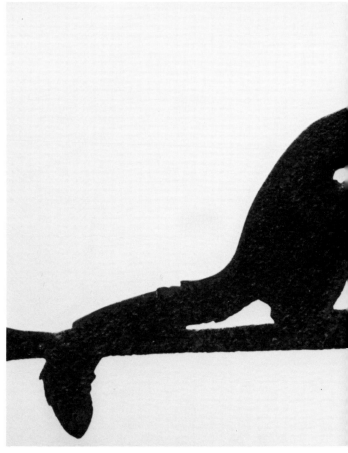

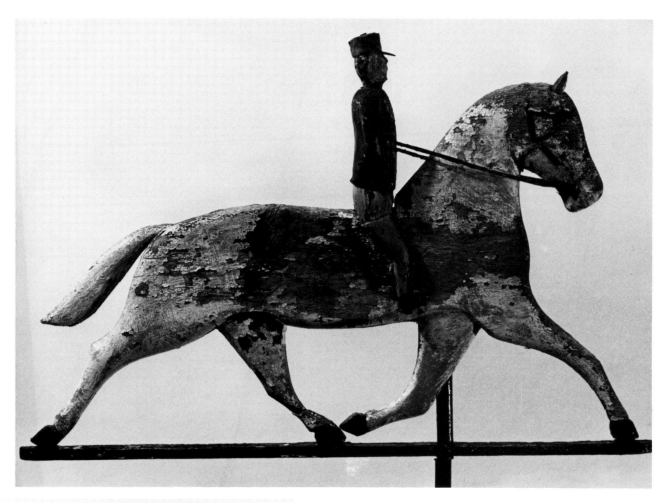

Horse and Rider—Wood and Metal: Private
Collection.

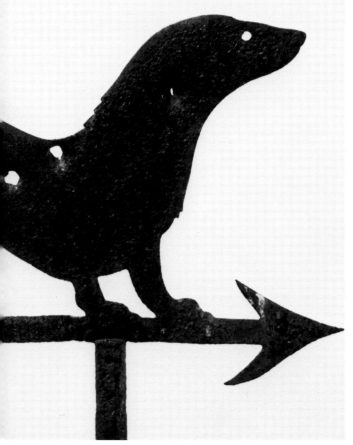

Mink—Sheet Iron: Private Collection.

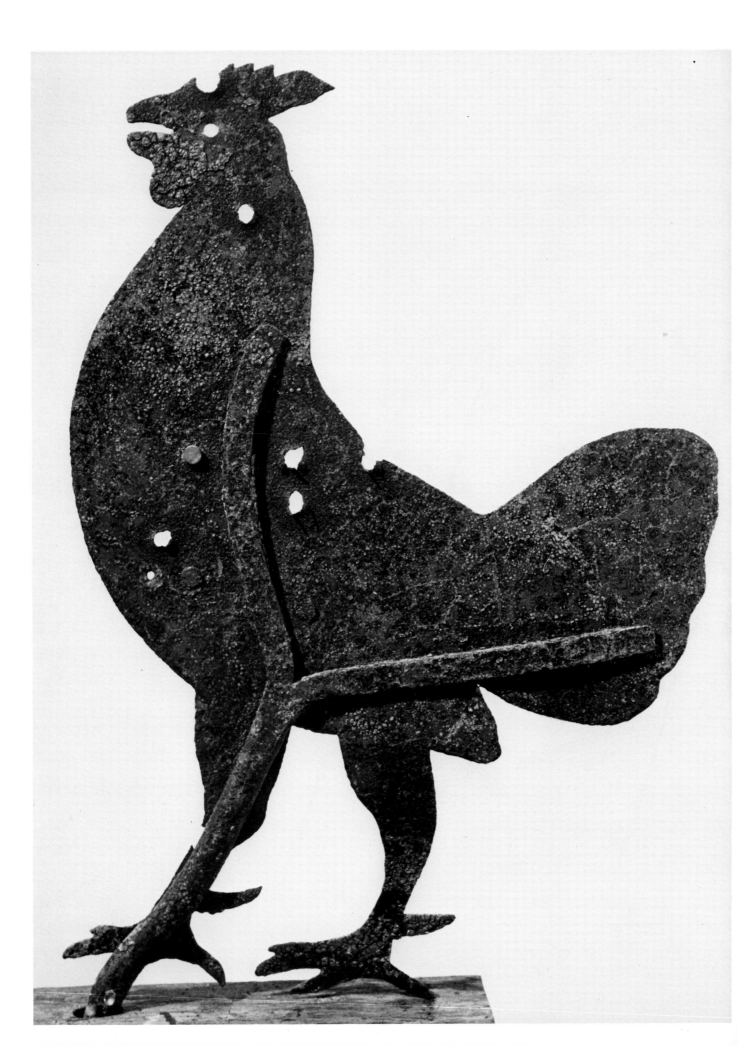

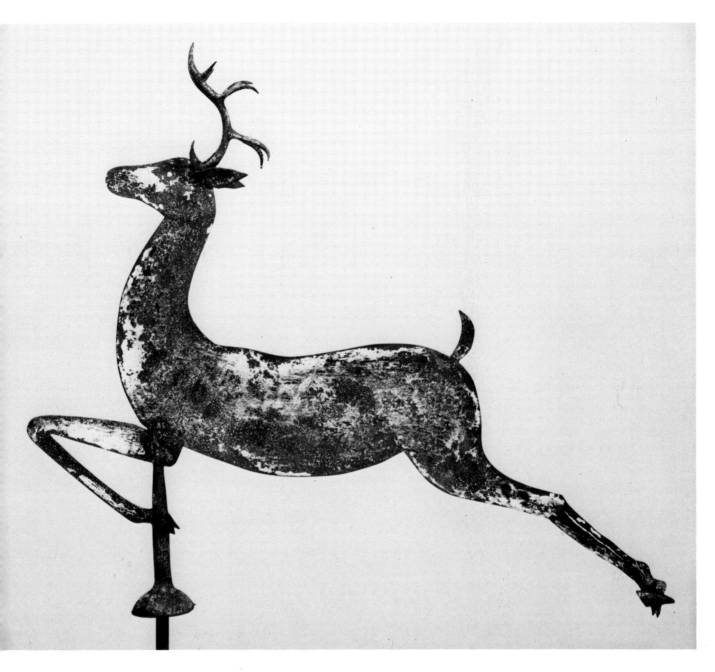

Stag—Sheet Iron: Private Collection.

Rooster—Sheet Iron: Private Collection.

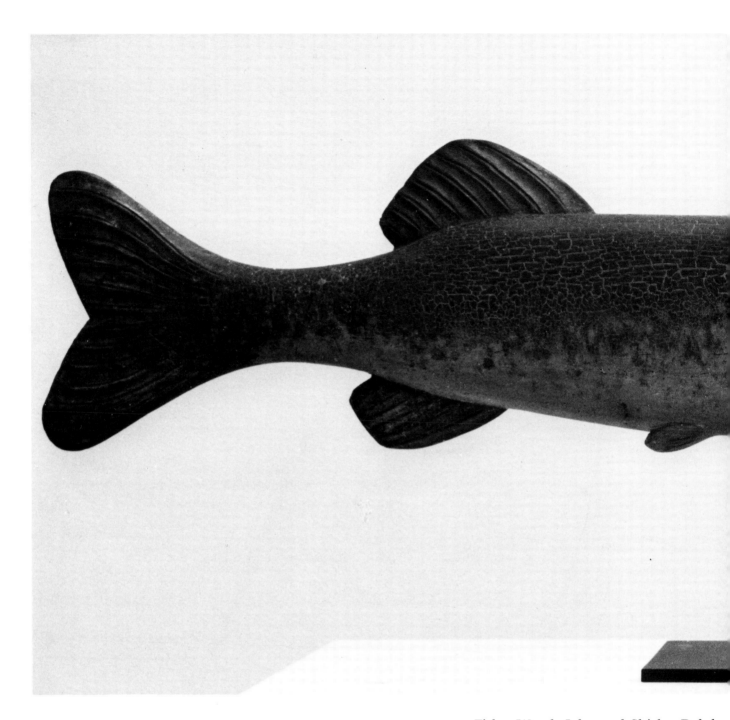

Fish—Wood: John and Shirley Delph.

Touring Car—Copper: Hill Gallery.

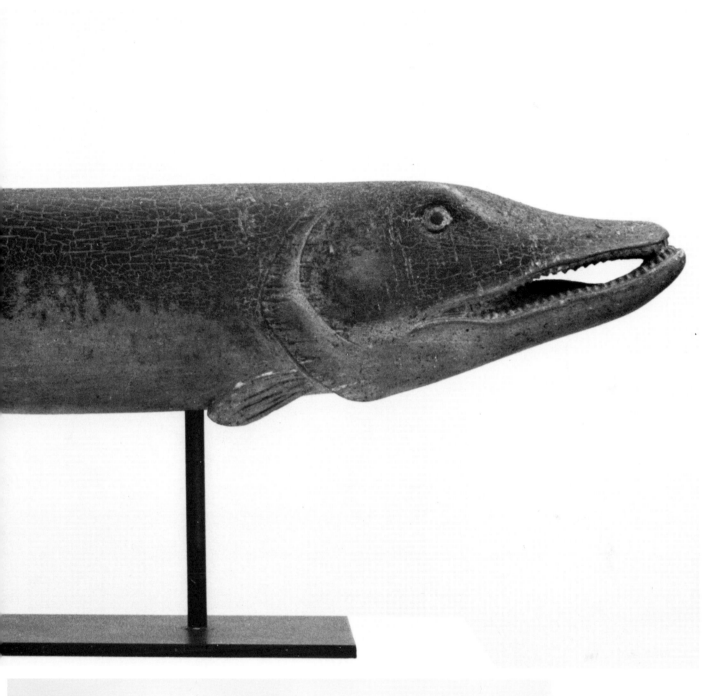

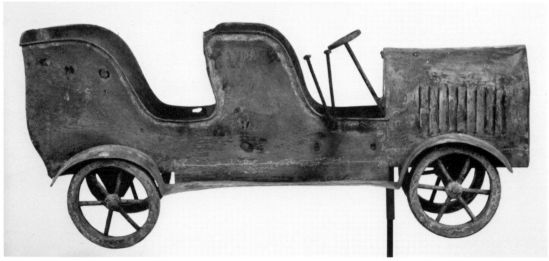

99

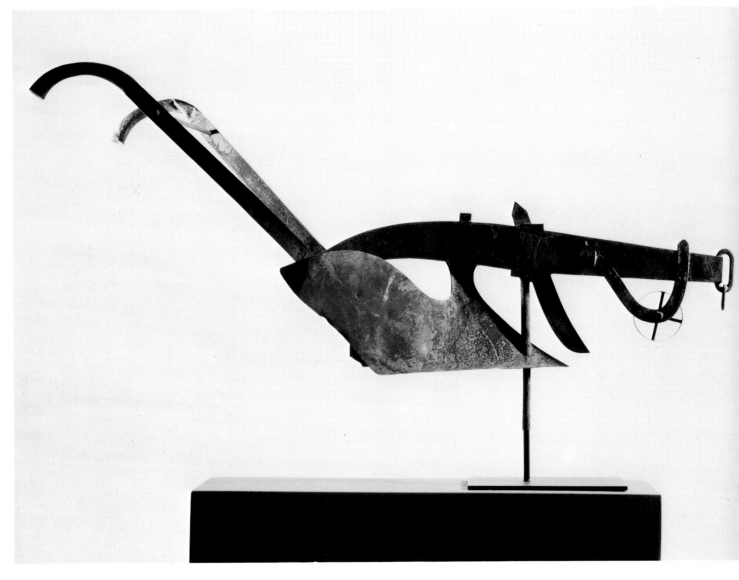

Plow—Copper and Brass: Ricco-Johnson Gallery.

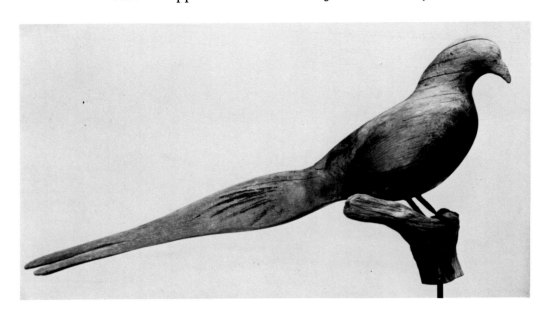

Pheasant—Wood: Barry Wolf.

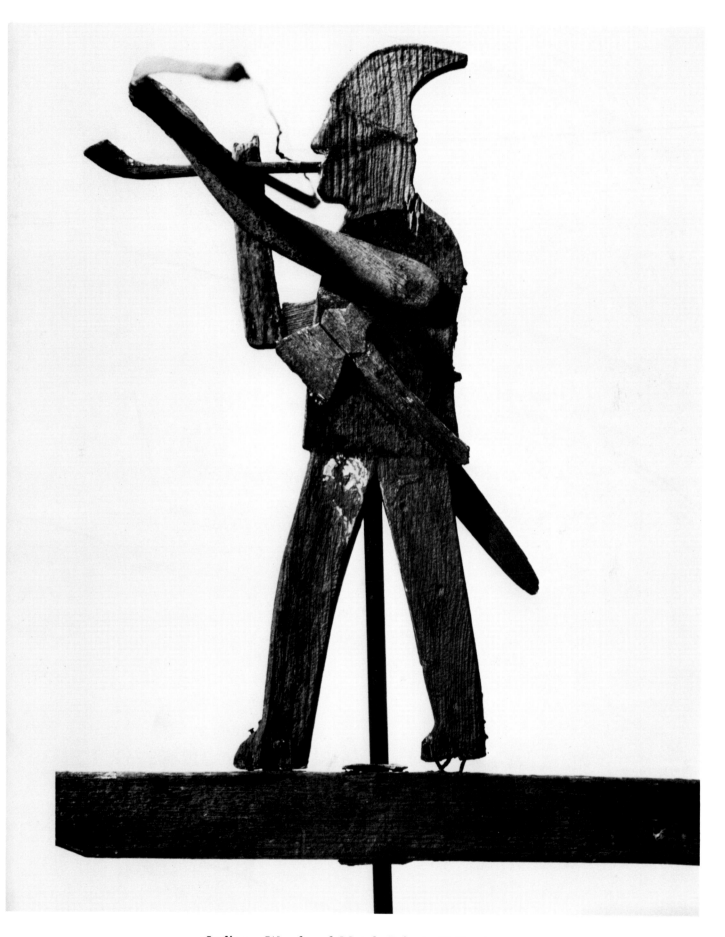

Indian — Wood and Metal: Private Collection.

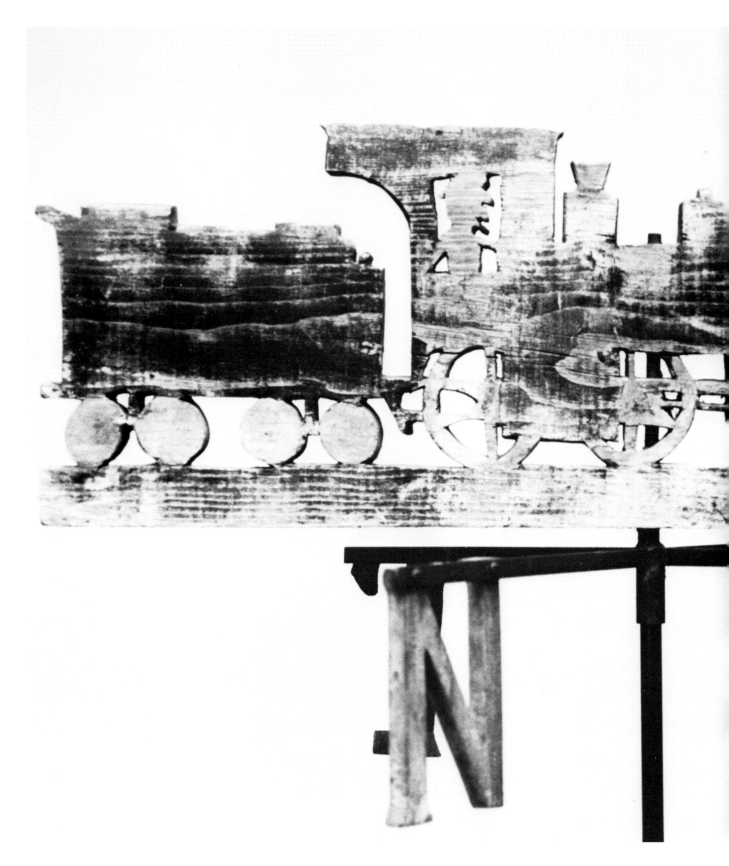

Locomotive—Wood and Metal: David Davies.

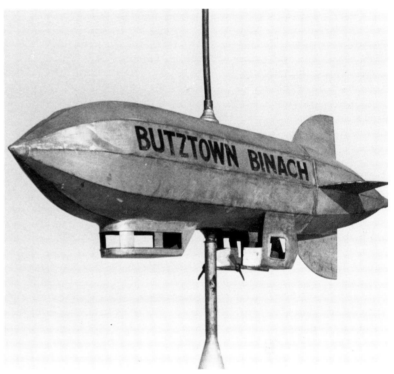

Derigible—Sheet Iron: Samuel Pennington.

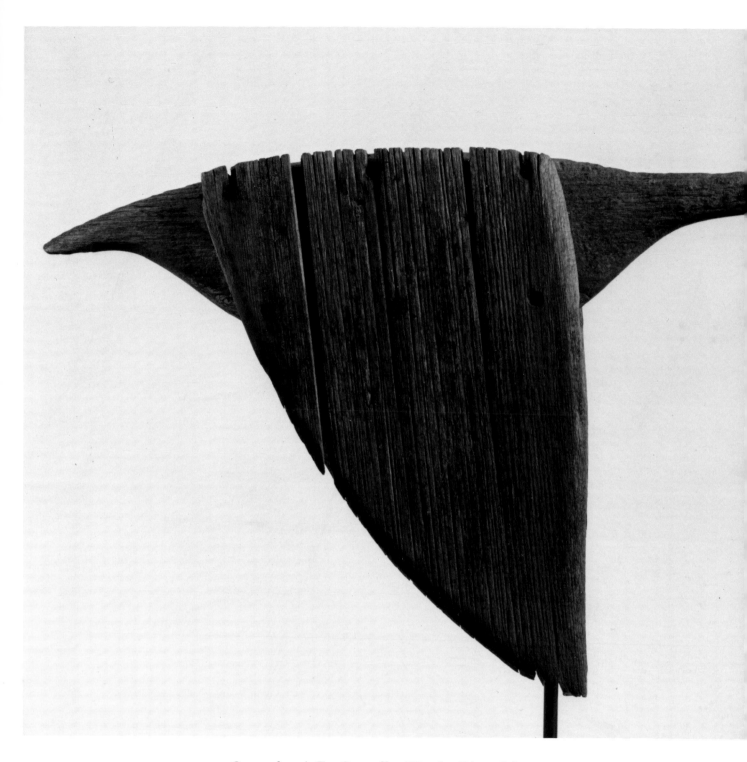

Goose by A.E. Crowell — Wood: Ricco-Johnson
Gallery.

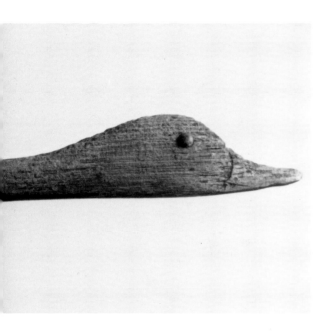

Horse — Wood and Metal: Ricco-Johnson Gallery.

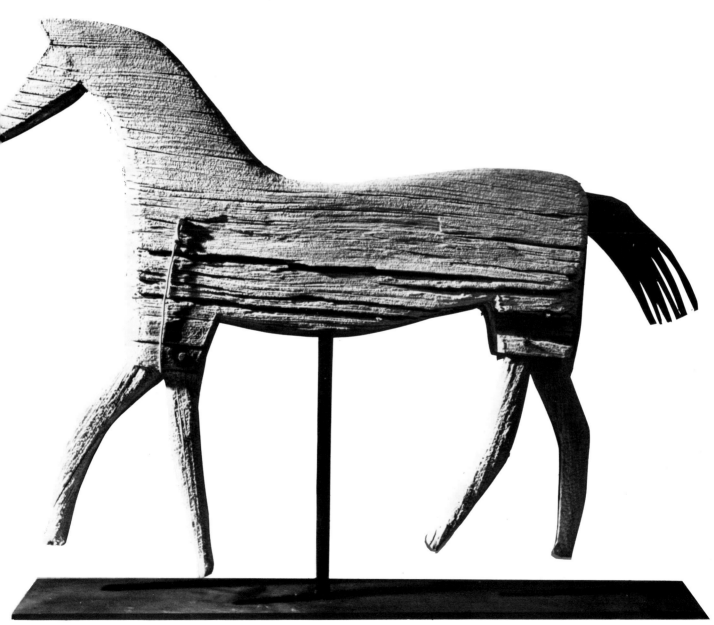

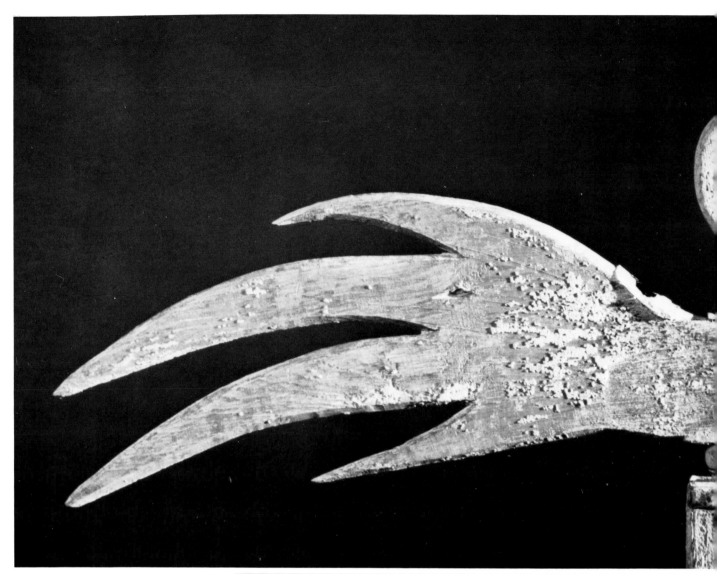

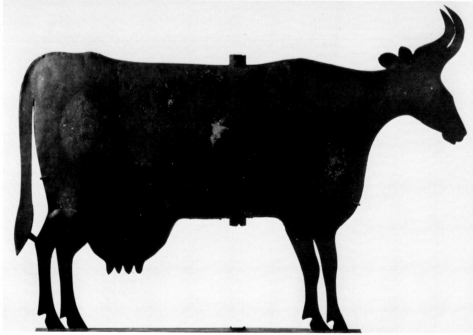

Cow—Sheet Iron: Ricco-Johnson Gallery.

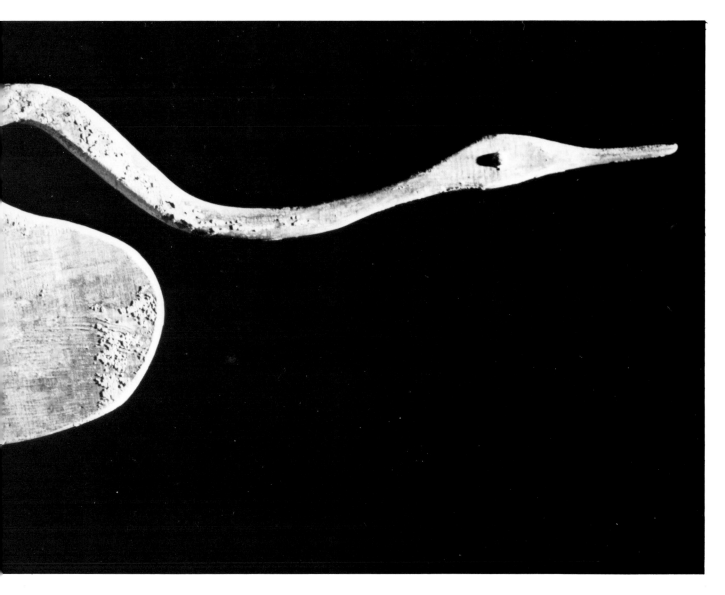

Swan—Wood: Ricco-Johnson Gallery.

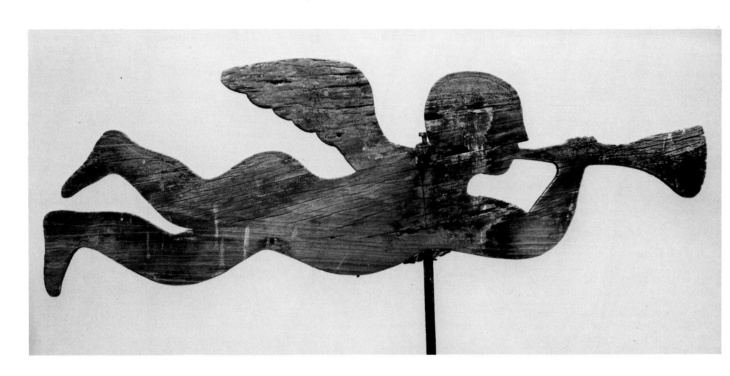

Gabriel—Wood: Ricco-Johnson Gallery.

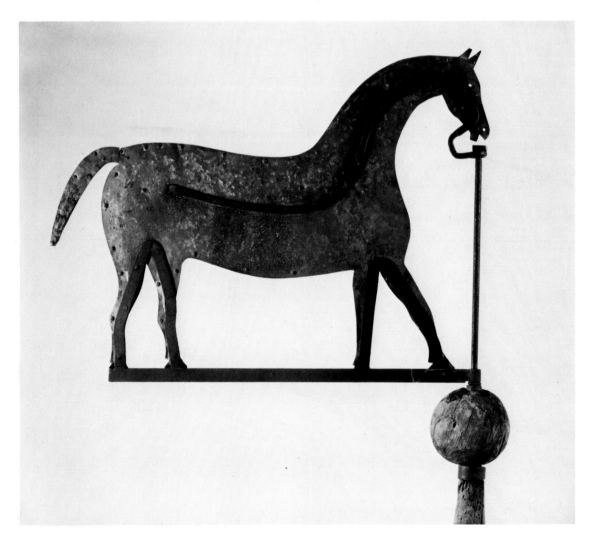

Horse—Sheet Iron: Ricco-Johnson Gallery.

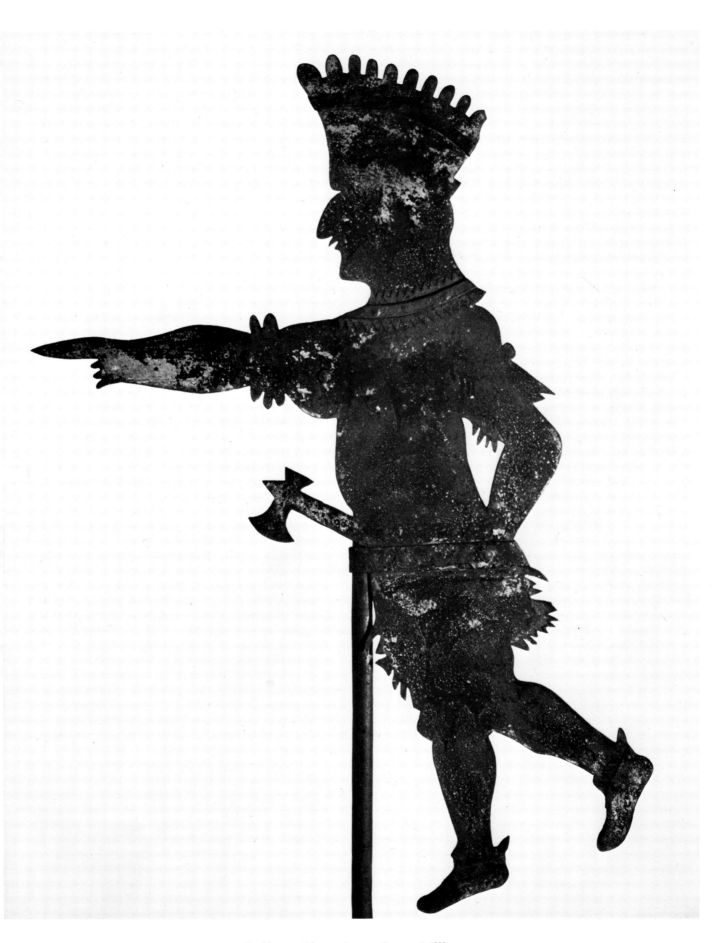

Indian—Sheet Iron: Steve Miller.

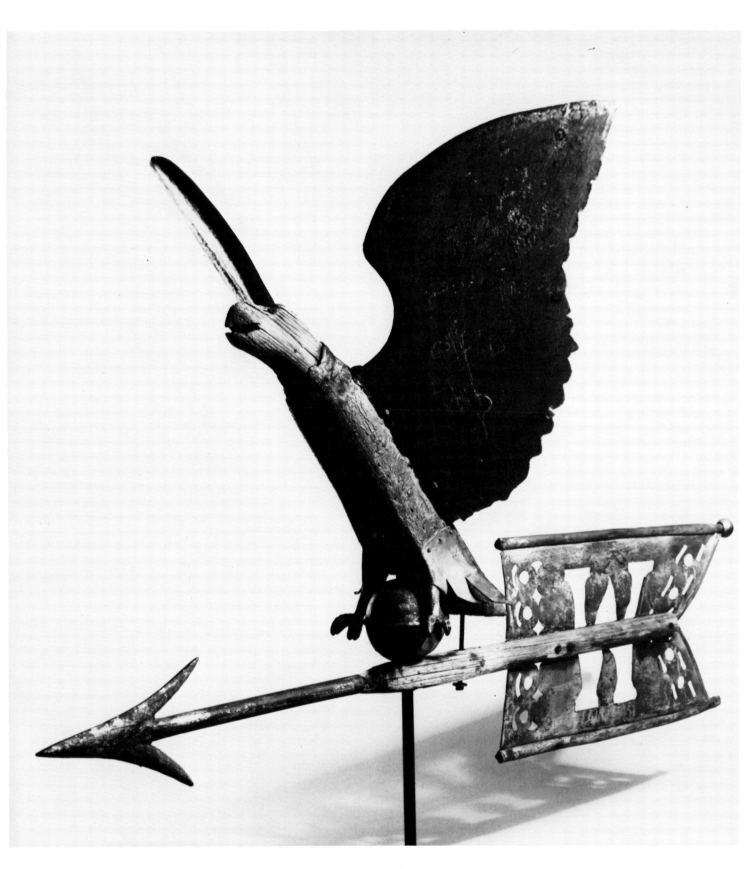

Eagle—Wood and Metal: Ricco-Johnson Gallery.

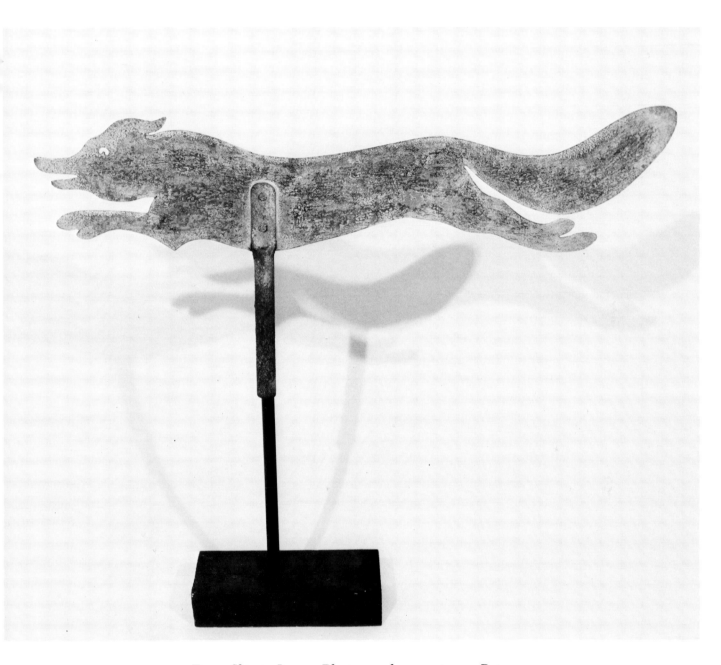

Fox—Sheet Iron. Photograph courtesy: Peter Schiffer.

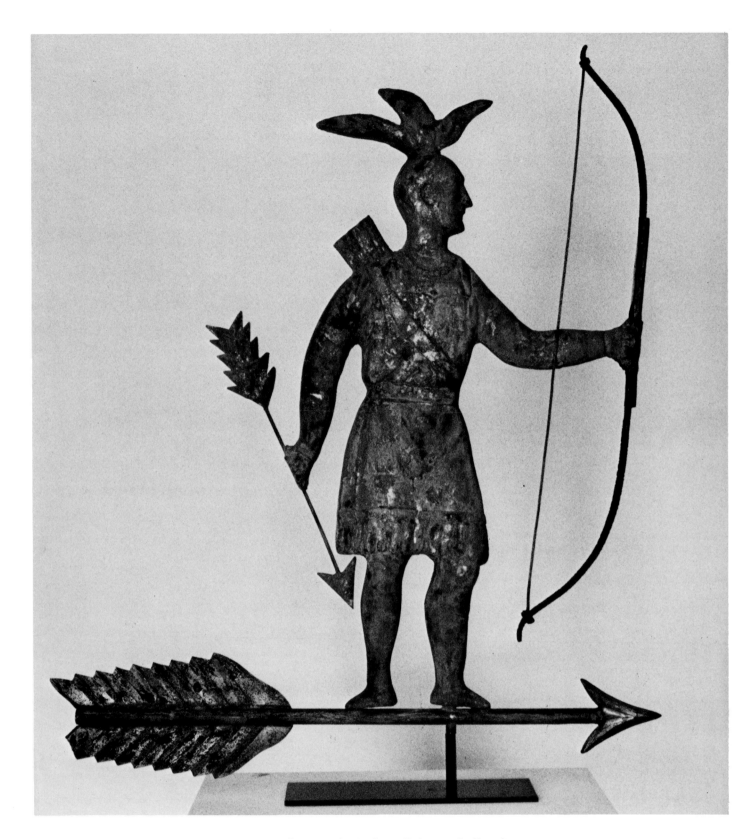

Massasoit, Harris & Co.: Private Collection.

Chapter 3

The Art of the Weathervane

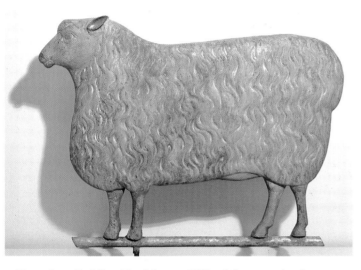

Ewe by L.W. Cushing, 28": Marna Anderson Gallery.

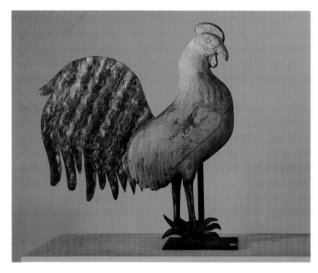

Small Rooster by J. Howard & Co.: Steve Miller Photograph.

When one examines the field of American Folk Art, one finds a drastic diversity in the available material. While it is possible for a primitive painting to be a great example of naive art, it does not hold true for *all* primitive paintings. One sees more *bad* paintings labeled *primitive* every day. This holds true in the field of Folk Sculpture as well.

Weathervanes have long been considered a major force in the field of Folk Sculpture, and unfortunately too many collectors have bought and exhibited what should properly be considered *artifacts* as art. What separates the art from the artifact is an almost intangible quality, one which brings the weathervane above its intended purpose into the field of sculpture. One of the most beautiful weathervanes that I have owned was sold to a collector of French Impressionist paintings who did not know, and did not care what its original purpose was. The fact that it was a deer weathervane by Johnathan Howard was only of secondary importance to its beauty.

Much of the beauty of folk sculpture is the patina, or surface appearance after so many years

of exposure to the elements. The bright golden finish of the original gilding was attractive when it graced the rooftop, but the dry, gritty gilding set off by the green oxidation of the copper literally glows when examined after 100 years exposure. A combination of a graceful silhouette, and a superb patina make up much of what is the beauty of a great weathervane. The *great* weathervane improves with time, and a true test is to live with the piece for a while. One rarely tires of great beauty quickly and a great weathervane will get better with time.

My entire collection of American Folk Sculpture consists of ten pieces, and I have purposely limited myself to that number. To acquire another piece means that I will sell one that I already own, and this seldom happens. Of the ten, only four are weathervanes and this was accidental, since first and foremost, I collect beautiful things, their original intent is unimportant.

Beauty alone is what constitutes the Art of the Weathervane....

113

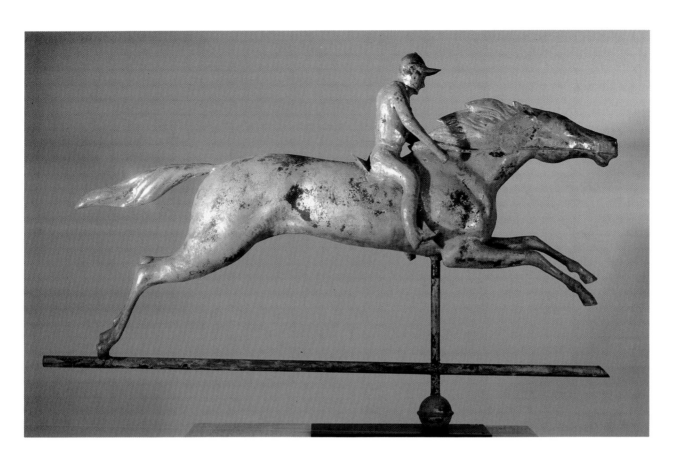

Horse and Jockey, J.W. Fiske, 32": Steve Miller
Photograph.

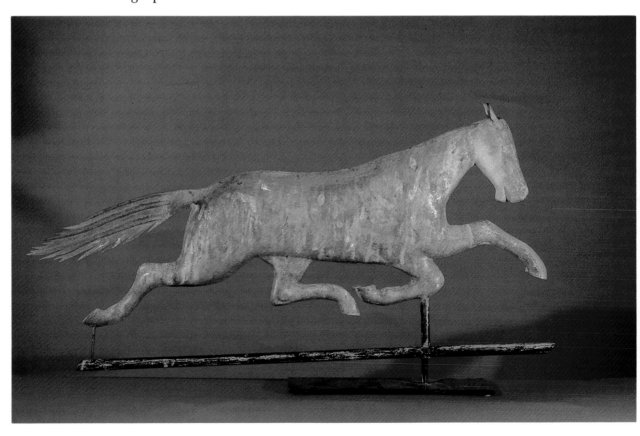

Very early Dexter by L.W. Cushing & Co.,
Waltham, Massachusetts. Ca. 1870: Private
Collection.

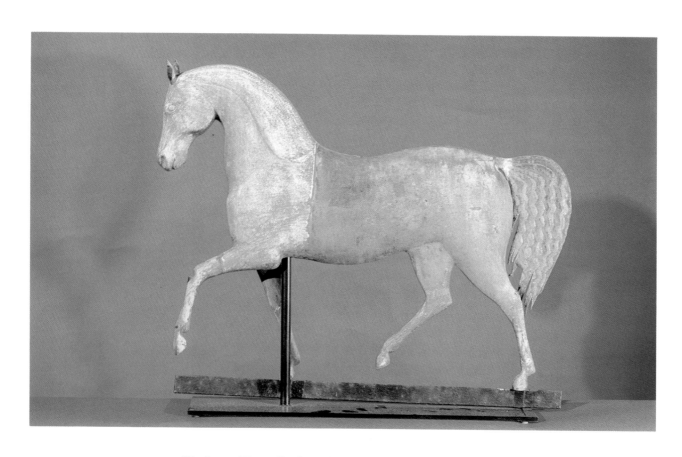

"Index Horse" by J. Howard & Co., W. Bridgewater, Massachusetts. Ca. 1855: Steve Miller.

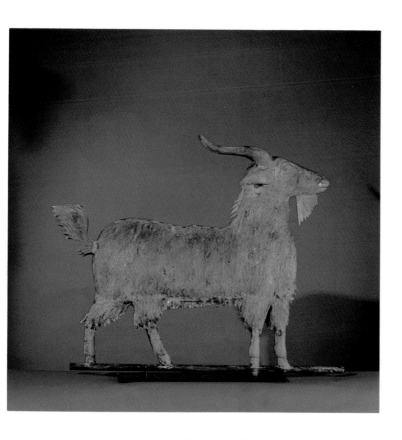

Goat: Steve Miller.

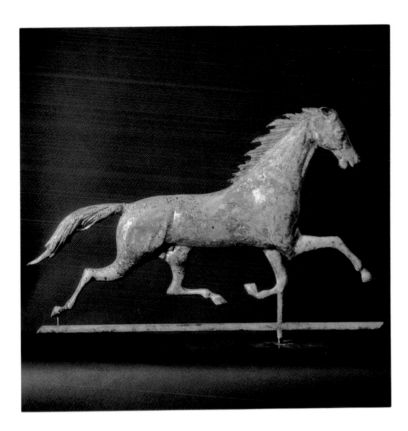

"Ethan Allen": Steve Miller.

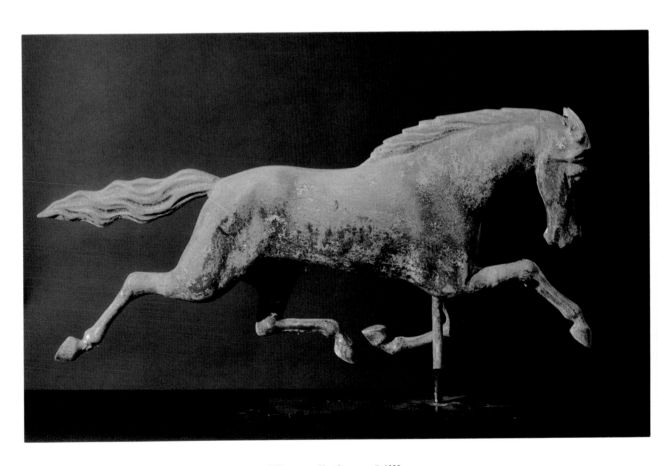

"Dexter": Steve Miller.

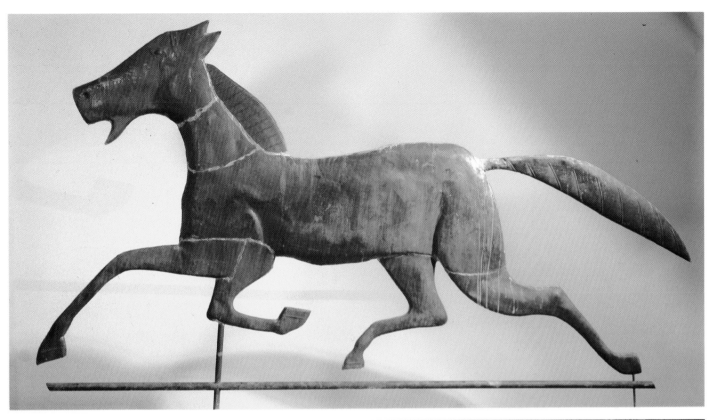

Running Horse 72" in length:
David Davies.

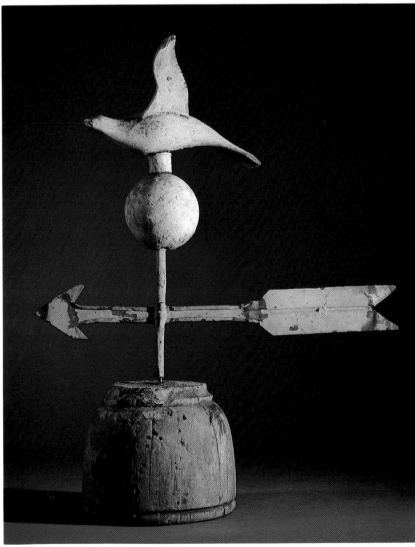

Dove — Polychromed Wood & Metal:
David Davies.

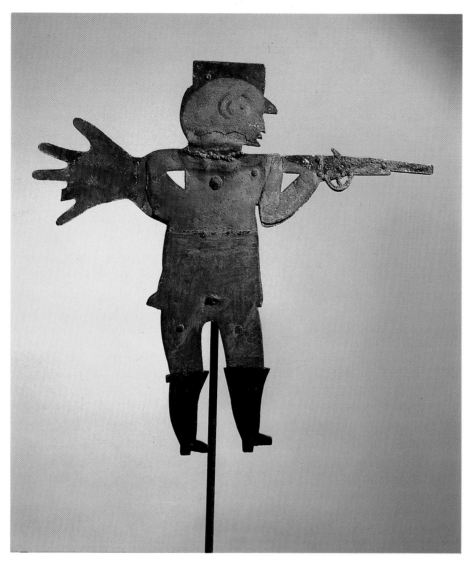

Hunter—Sheet Iron: David Davies.

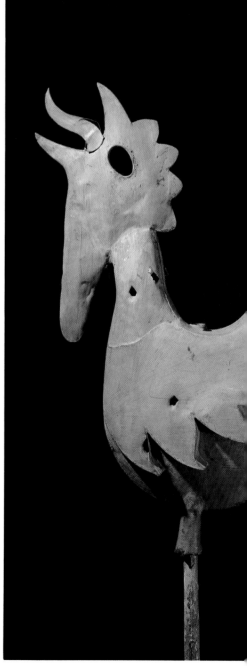

Cock from a New England church: David Davies.

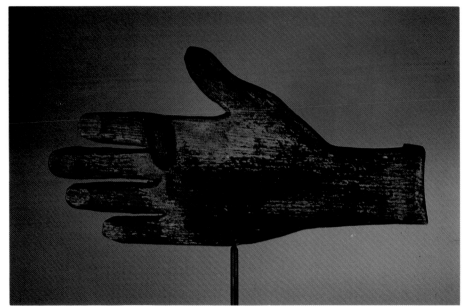

Hand—Wood: Ken and Ida Manko.

Sea Horse—Metal: Ken and Ida Manko.

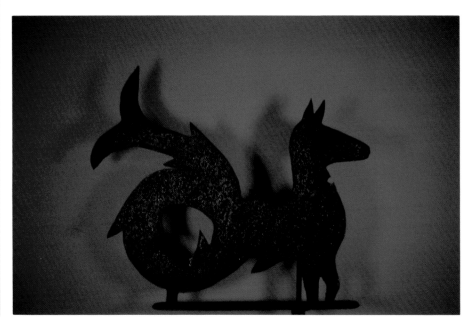

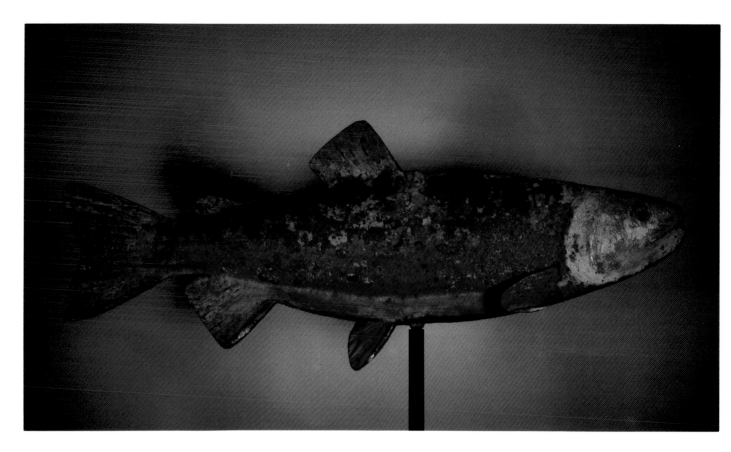

Fish—Metal: Ken and Ida Manko.

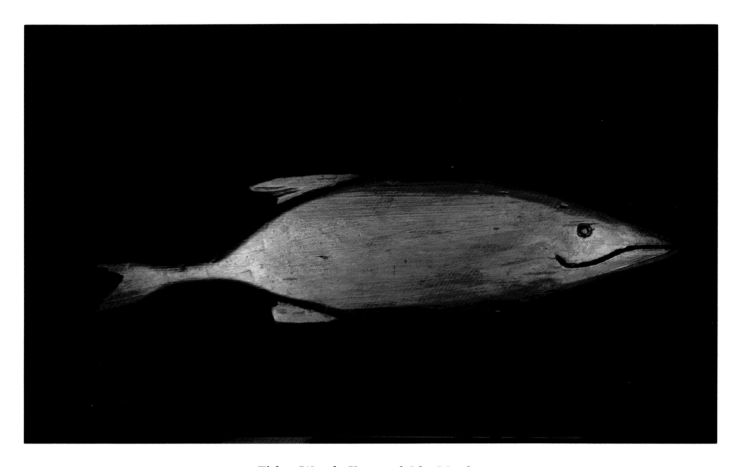

Fish—Wood: Ken and Ida Manko.

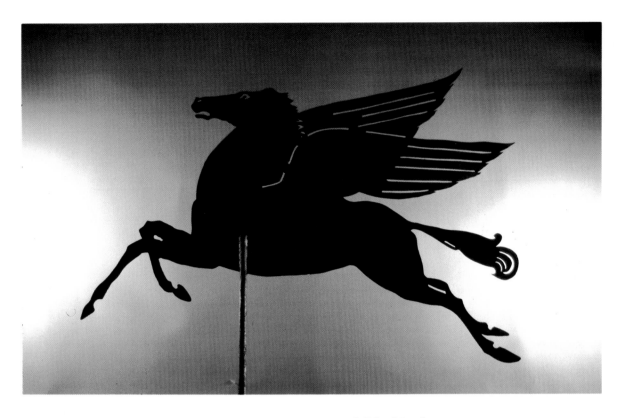

Pegasus—Brass: Ken and Ida Manko.

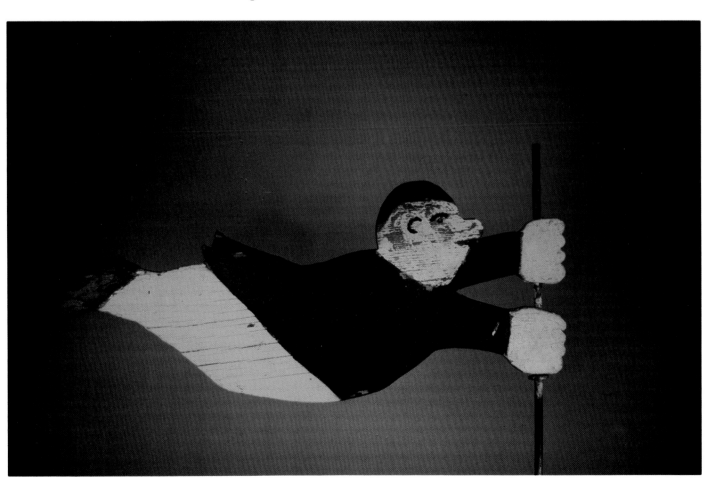

Man—Wood: Ken and Ida Manko.

121

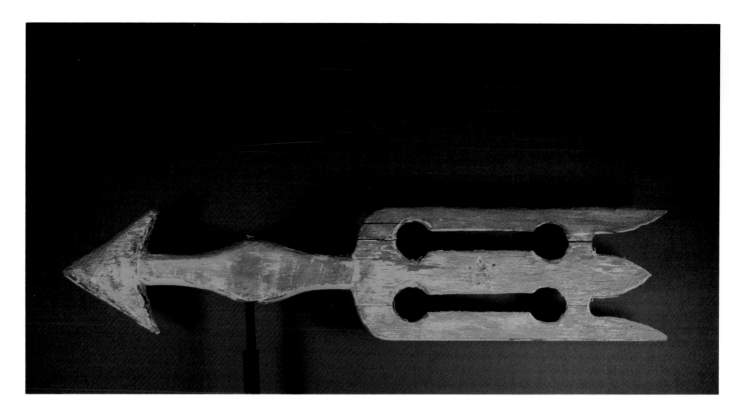

Arrow—Wood: Ken and Ida Manko.

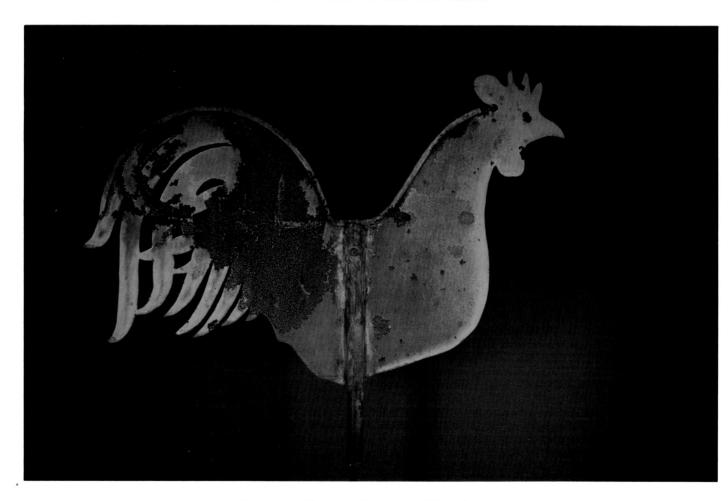

Rooster—Copper: Ken and Ida Manko.

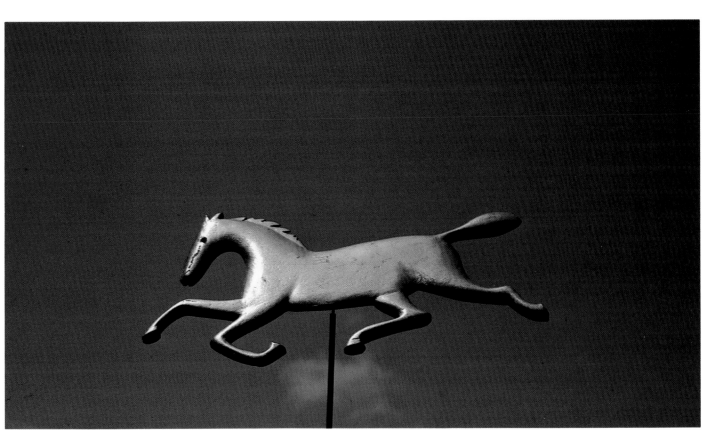

Horse—Wood: Ken and Ida Manko.

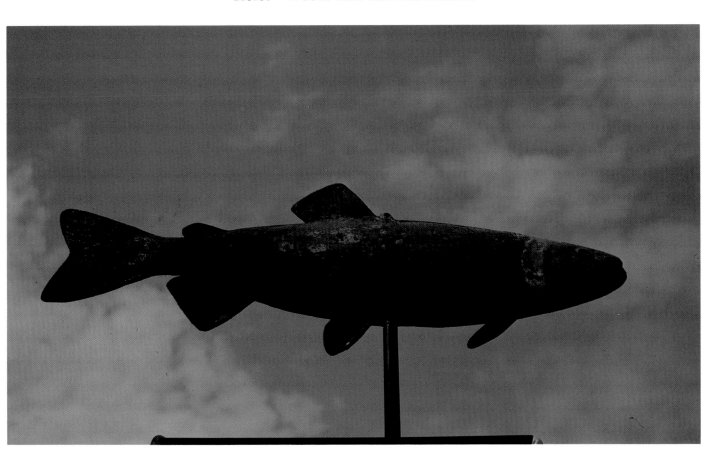

Cod Fish—Metal: Ken and Ida Manko.

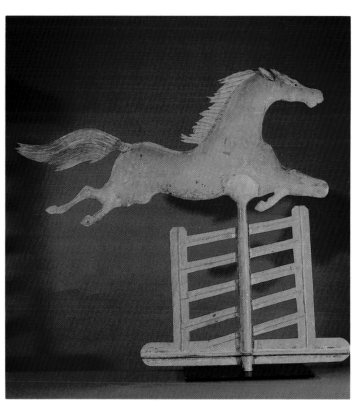

Flying Steeplechase Horse by A.L. Jewell & Co.:
Private Collection.

Eagle by A.L. Jewell & Co. ca. 1850: Steve Miller.

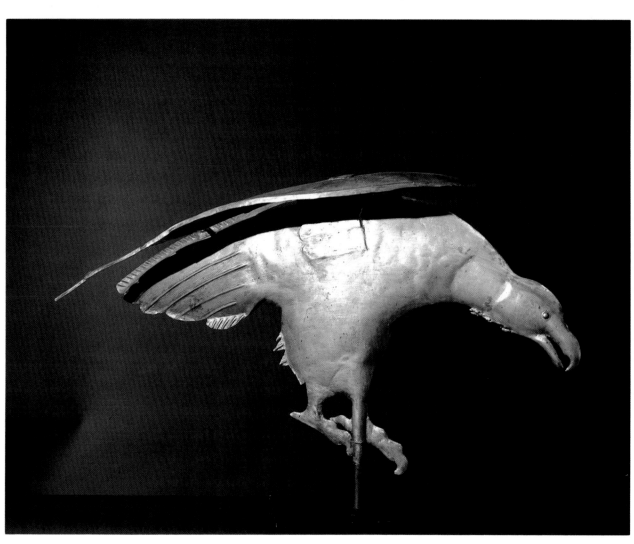

Goddess of Liberty: Private Collection.

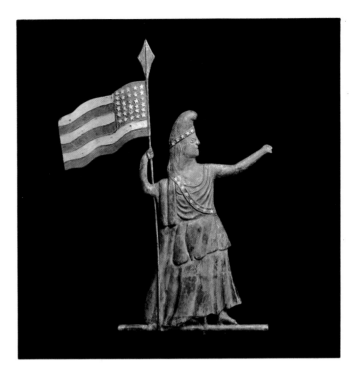

Black Hawk by Harris & Co.: Private Collection.

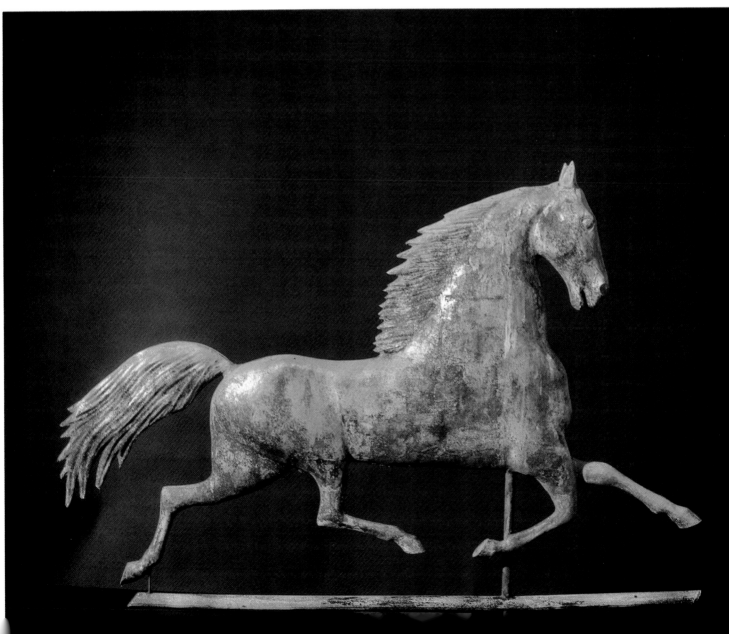

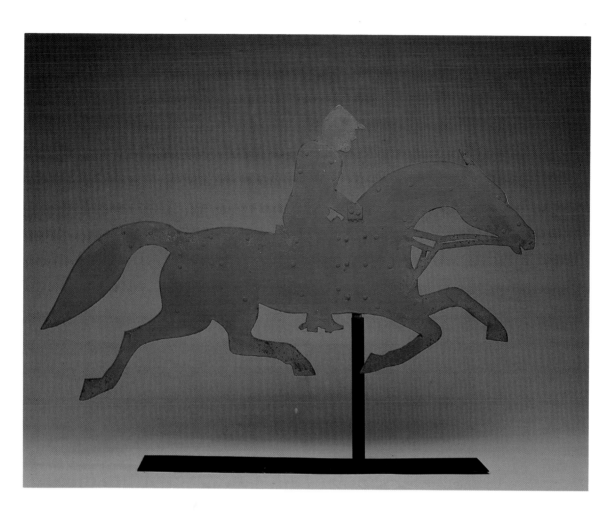

Horse and Rider: Private Collection.

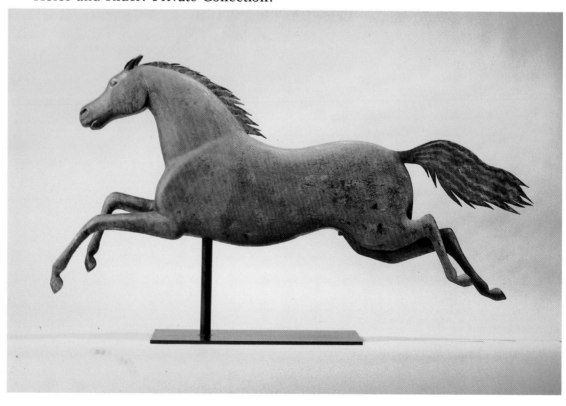

Running Horse, J. Howard & Co.: Dorothy Kaufman.

126

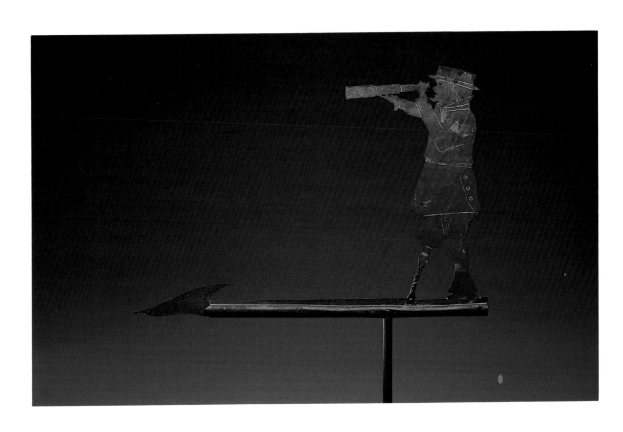

Sea Captain: Private Collection.

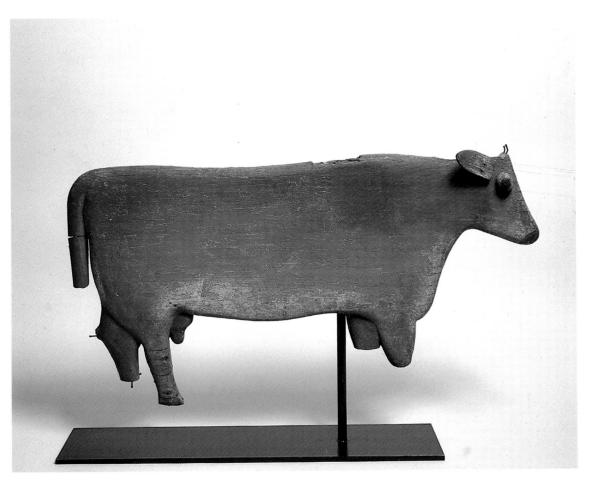

Cow: Marna Anderson.

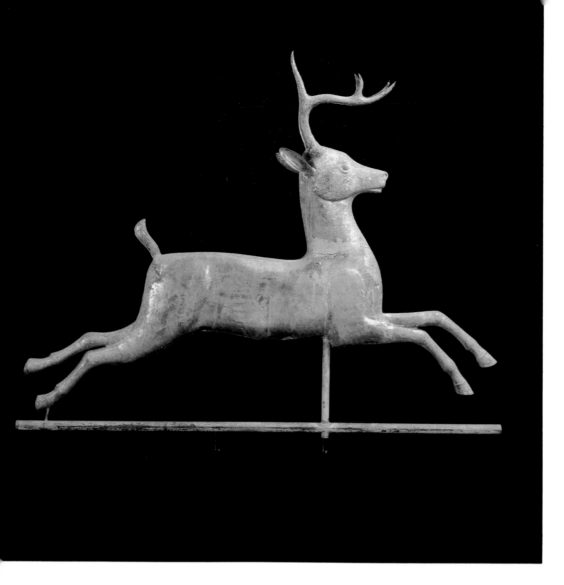

Running Deer: Dorothy Kaufman.

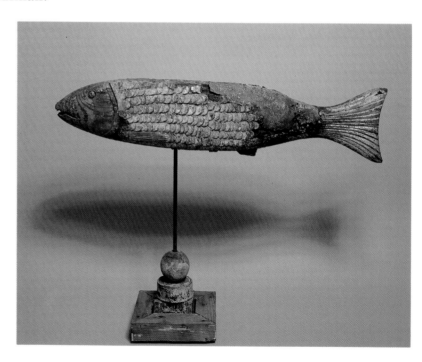

Fish: Marna Anderson.

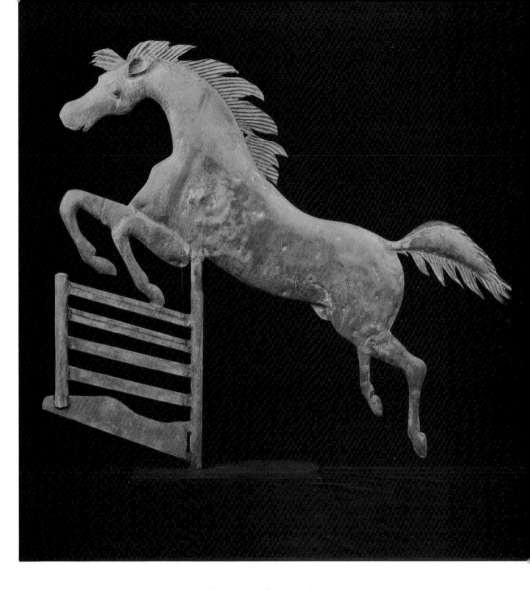

Steeplechase Horse: Marna Anderson.

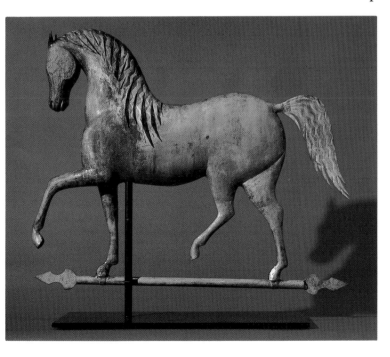

"Index" Horse, J. Howard: Steve Miller Photograph.

129

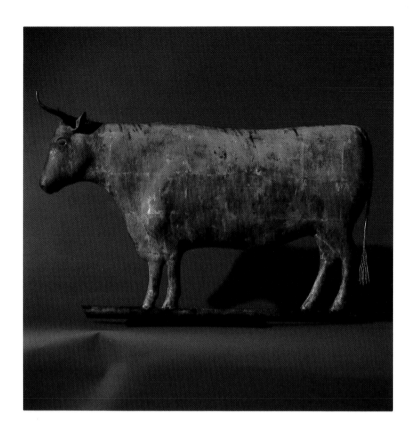

Bull, Cushing & White: Steve Miller Photograph.

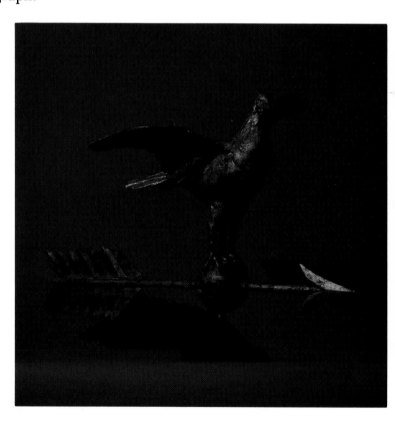

Pigeon: Steve Miller Photograph.

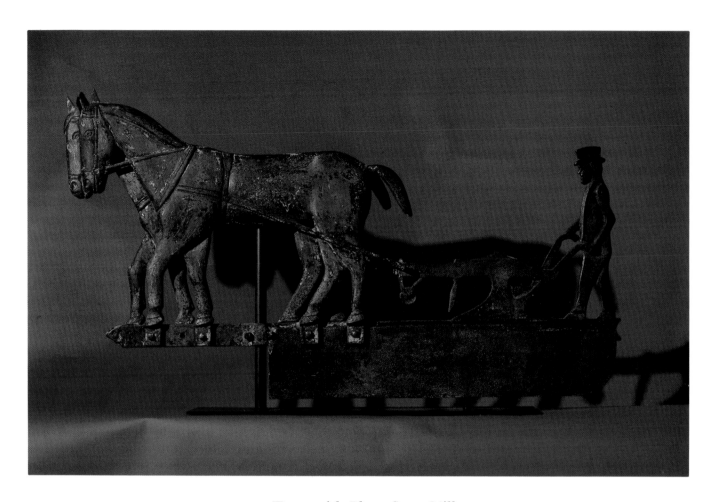

Team with Plow: Steve Miller.

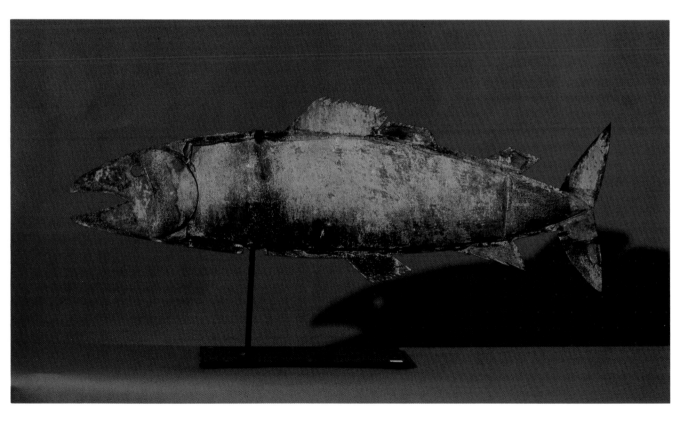

Salmon: Steve Miller Collection.

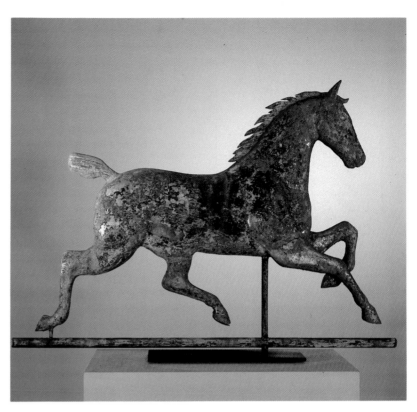

Hackney Horse: Private Collection.

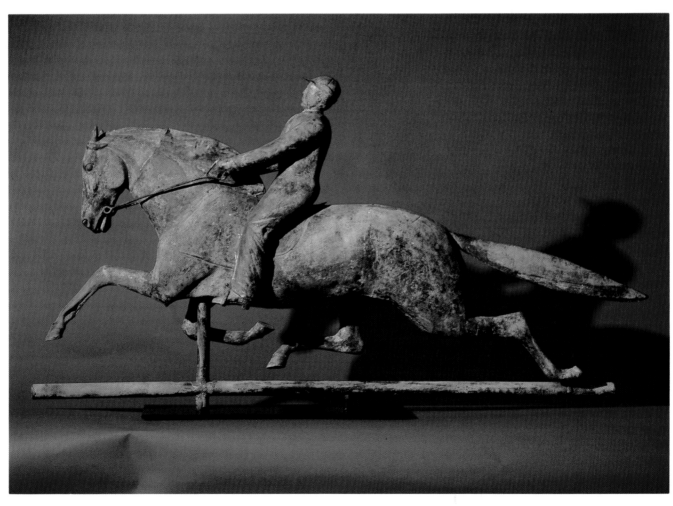

Dexter with Jockey, Cushing & White: Steve Miller.

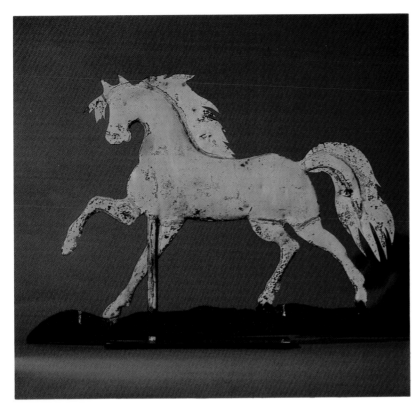

Prancing Horse: Steve Miller.

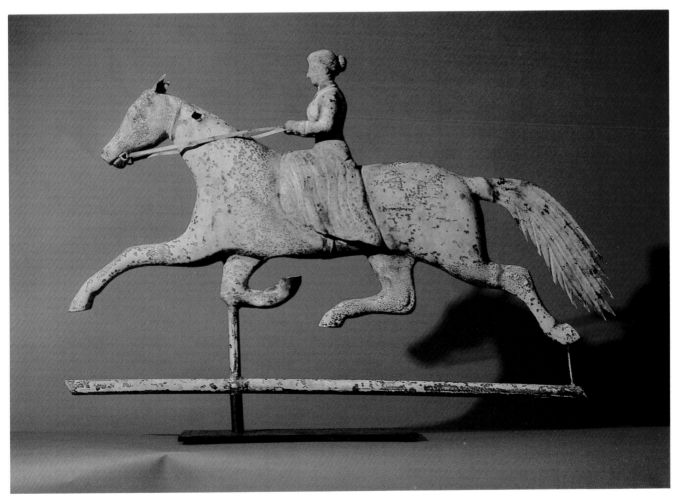

Sidesaddle Lady Rider: Steve Miller Photograph.

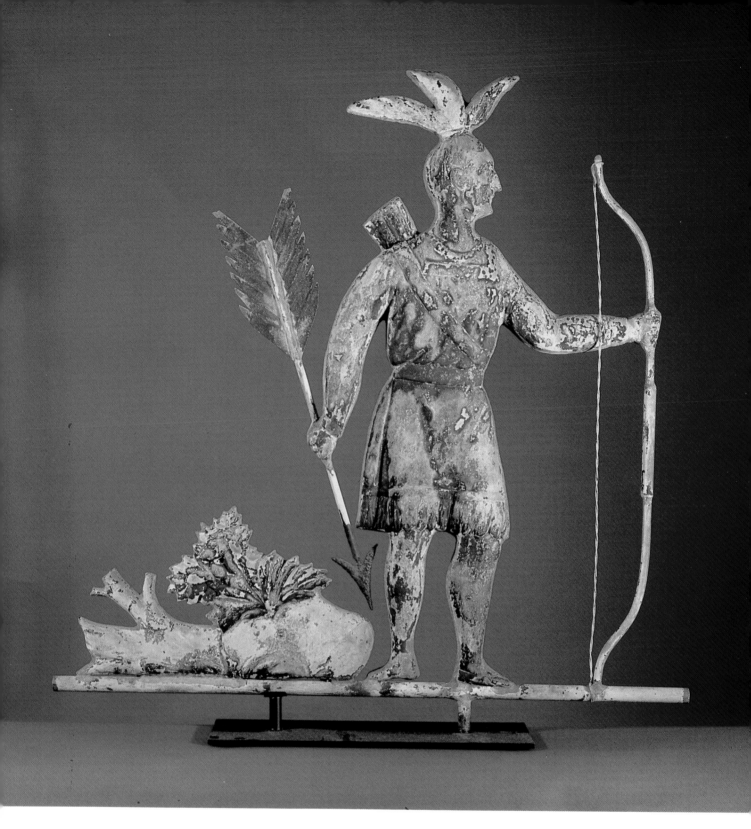

Massasoit, J. Harris & Co.: Private Collection.

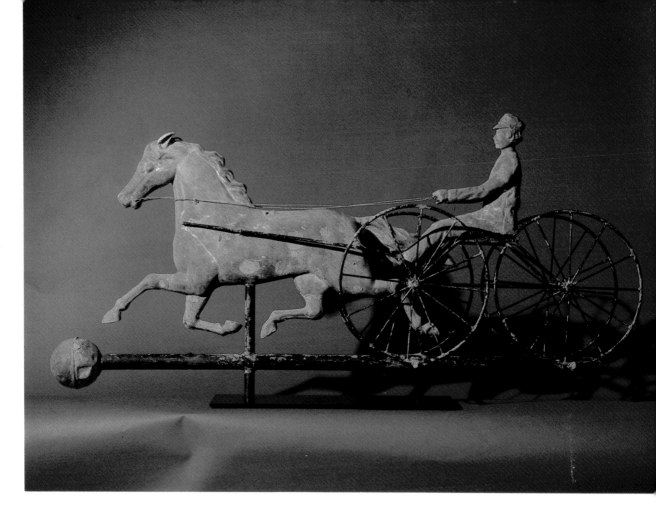

Four Wheel Sulky, Harris & Co.: Jas. Kronen
Photograph.

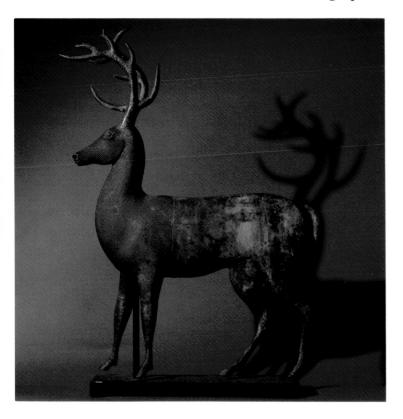

Deer, J. Howard & Co.: Steve Miller Collection.

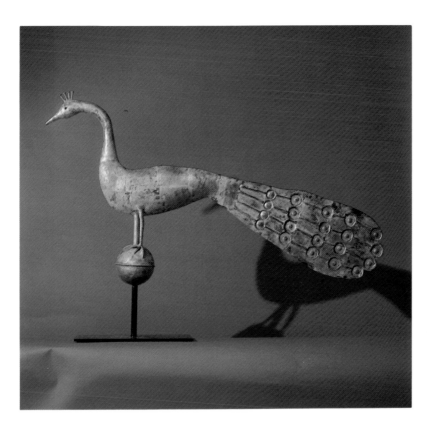

Peacock, A.L. Jewell & Co.: Steve Miller.

Angle Gabriel: Private Collection.

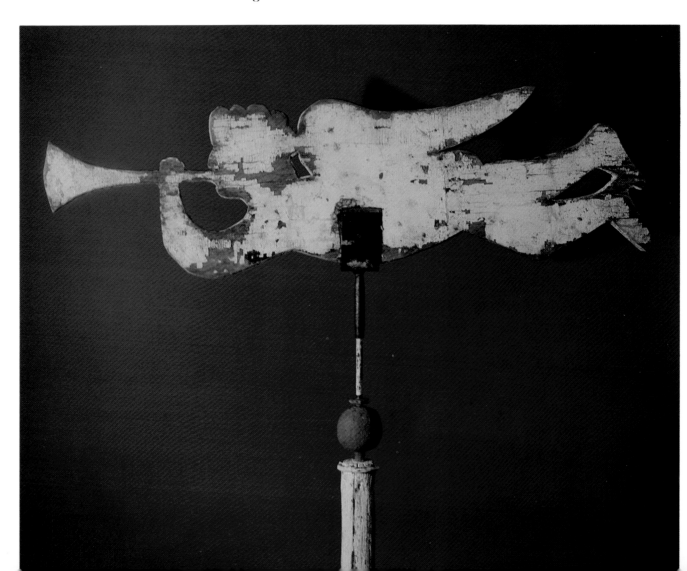

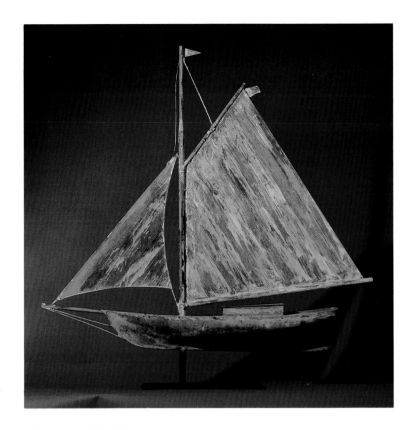

Sailboat, L.W. Cushing: Mr. and Mrs. George Wick.

Pig, L.W. Cushing: Private Collection.

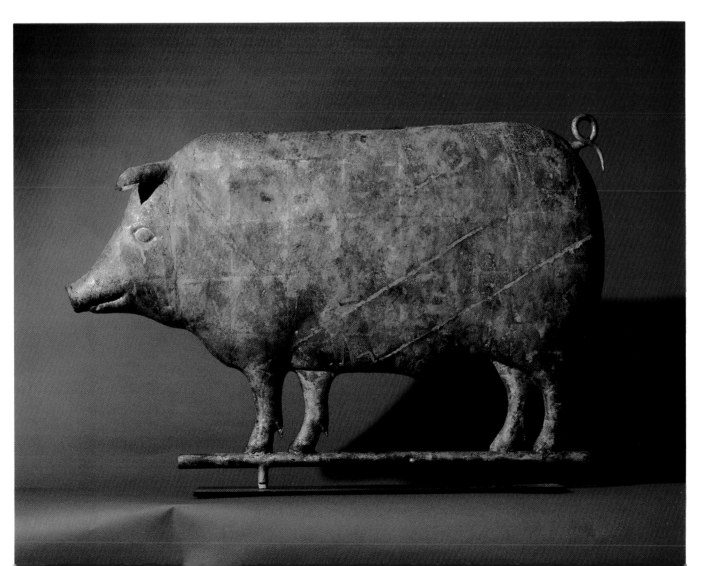

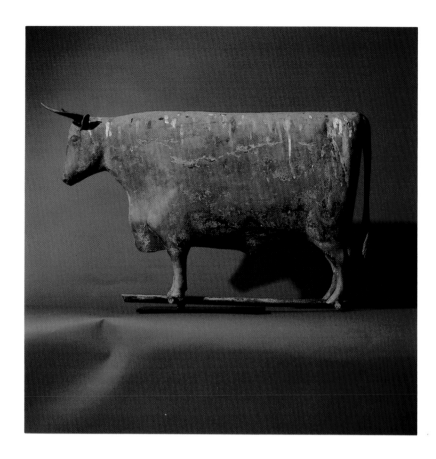

Ox, Harris & Co.: Steve Miller.

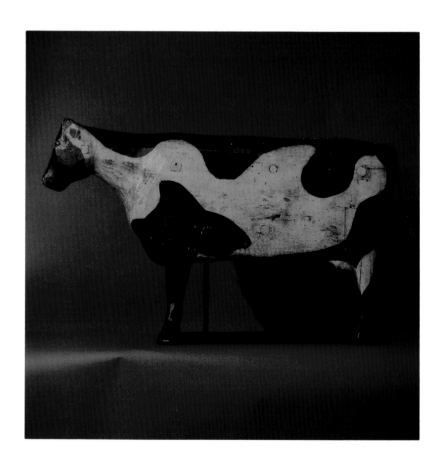

Cow: Steve Miller Collection.

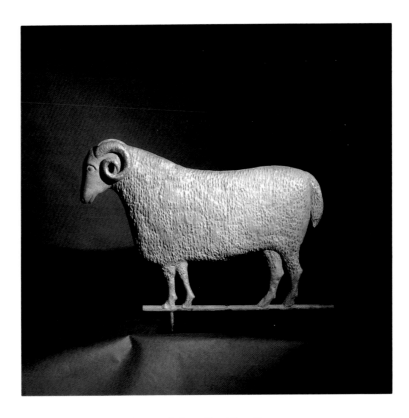

Ram, J.W. Fiske: Martin and Estelle
Shack.

Goat: Martin and Estelle Shack.

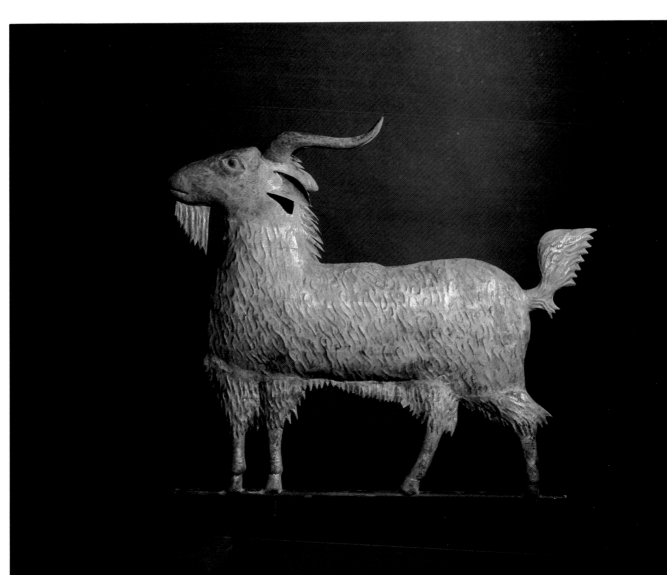

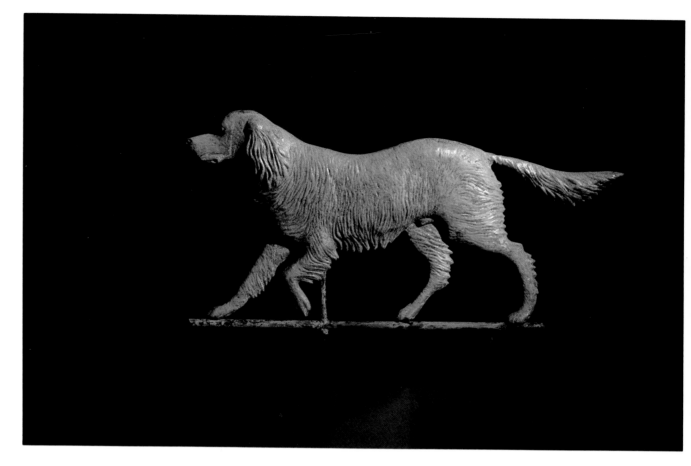

"Ranger", L.W. Cushing: Martin and Estelle Shack.

Four Wheel Sulky, Fiske: Steve Miller Photograph.

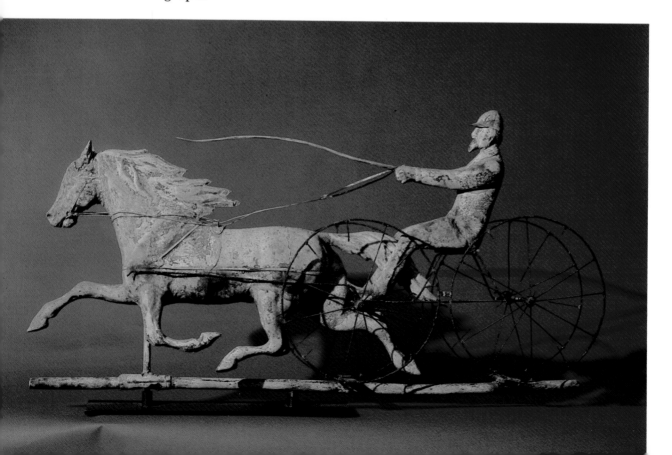

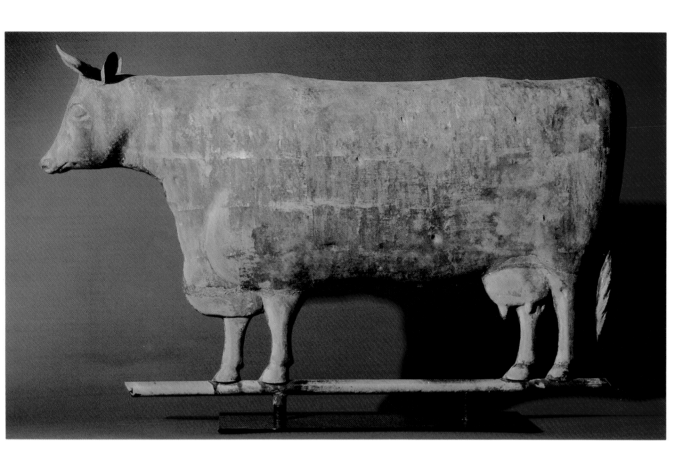

Bull, L.W. Cushing: Steve Miller Photograph.

Formal Horse: Steve Miller Photograph.

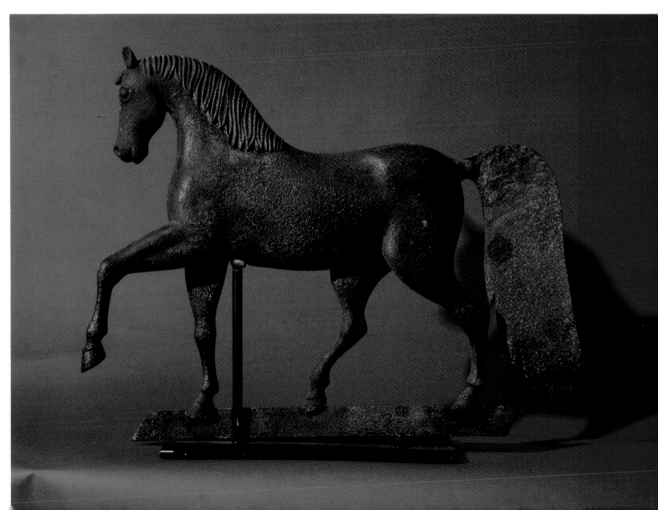

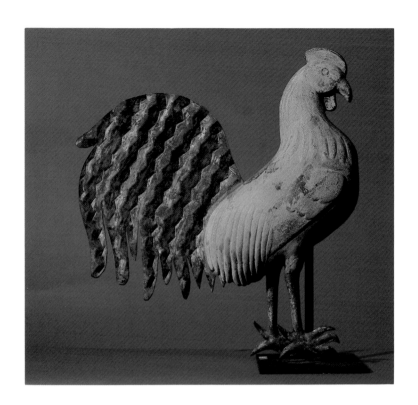

Rooster, J. Howard & Co.: Steve Miller Photograph.

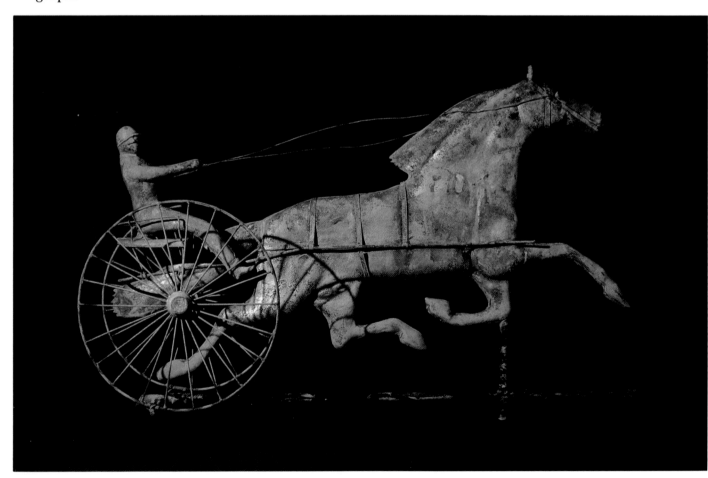

Horse and Sulky: Private Collection.

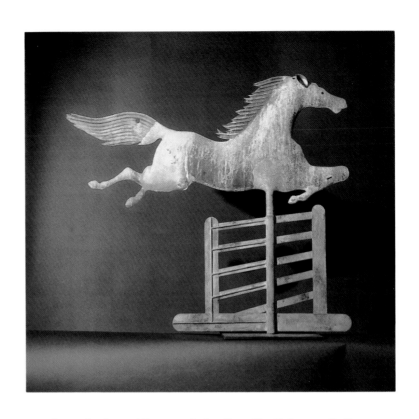

Steeplechase Horse, A.L. Jewell: Private Collection.

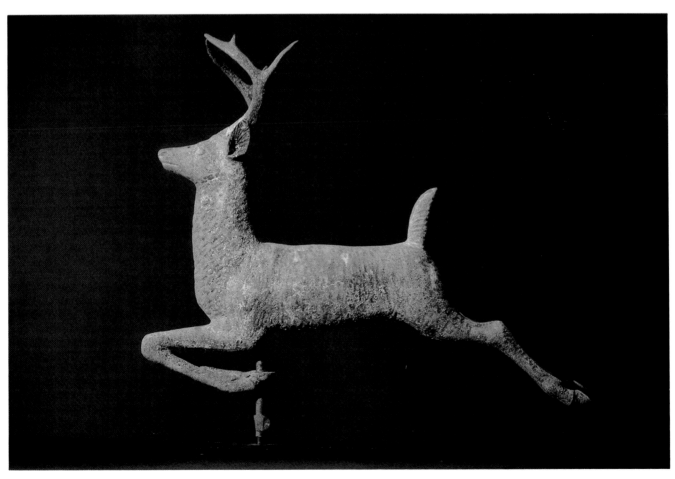

Leaping Stag, L.W. Cushing: Private Collection.

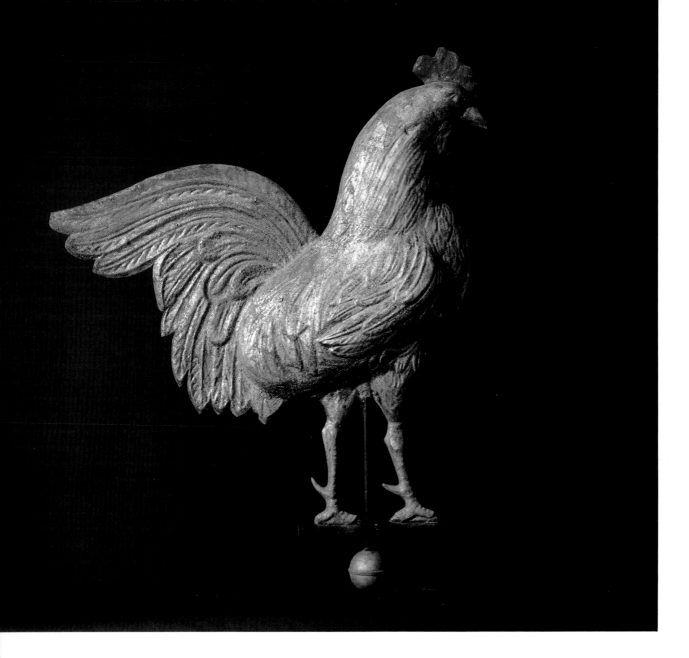

Rooster: Private Collection.

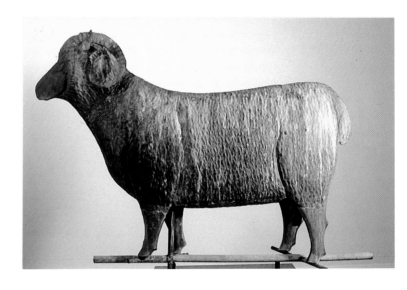

Ram: Private Collection.

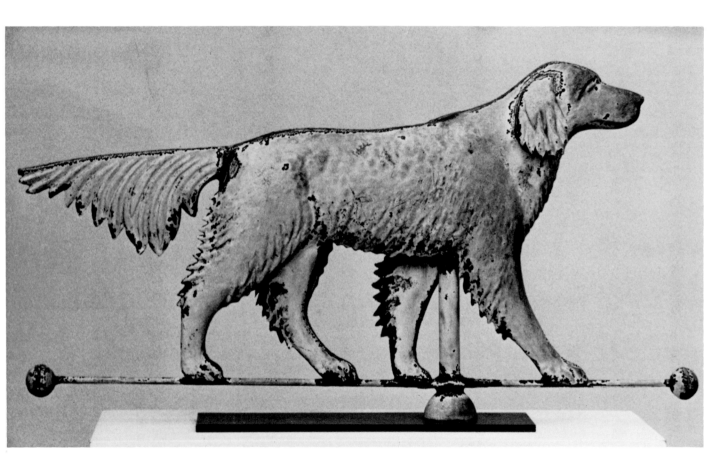

Setter: Private Collection.

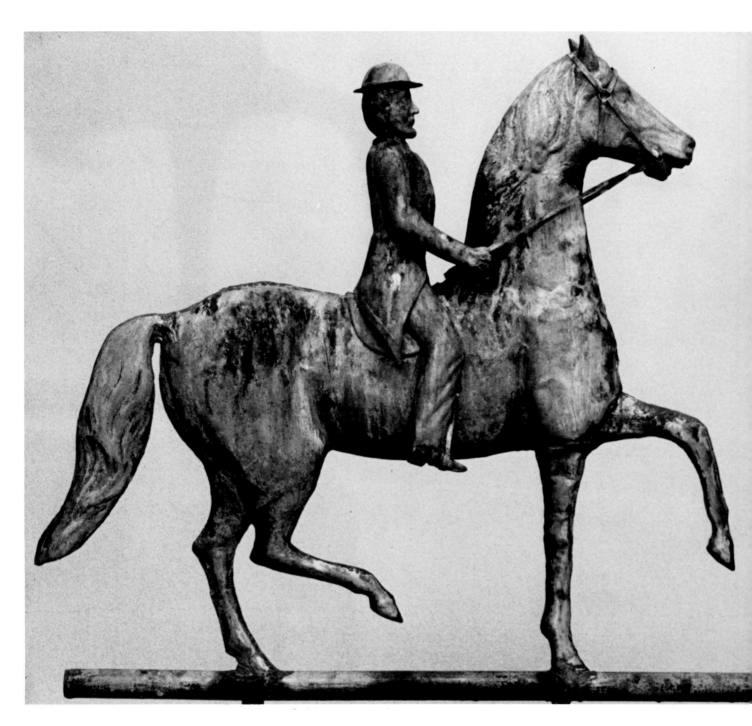

Civilian Rider, J. Fiske & Co.: Private Collection.

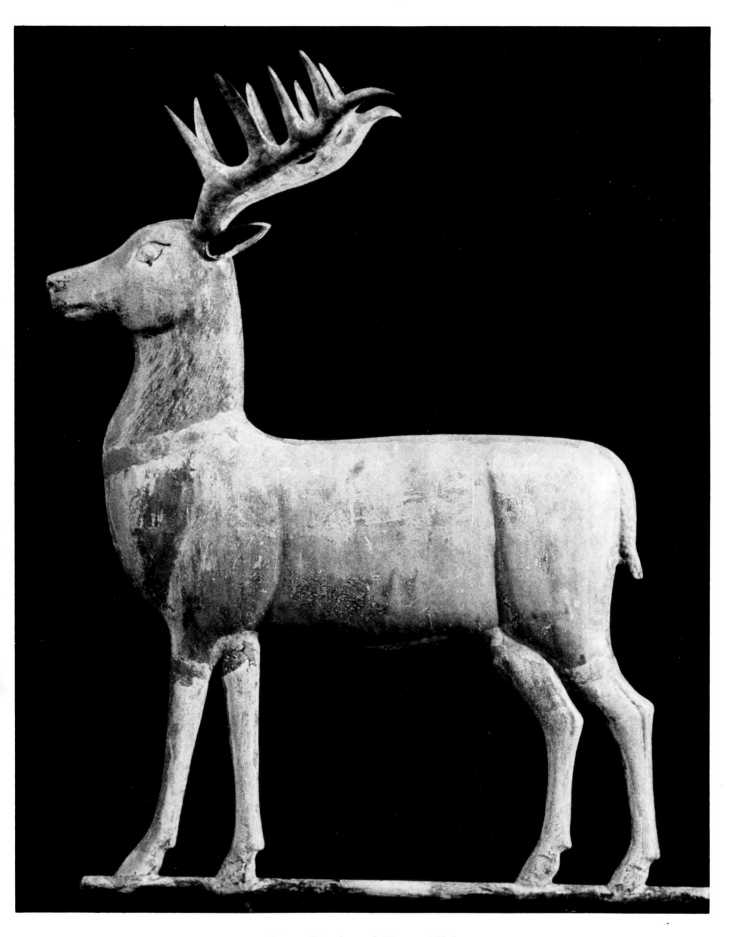

Deer: Frank and Karen Miele.

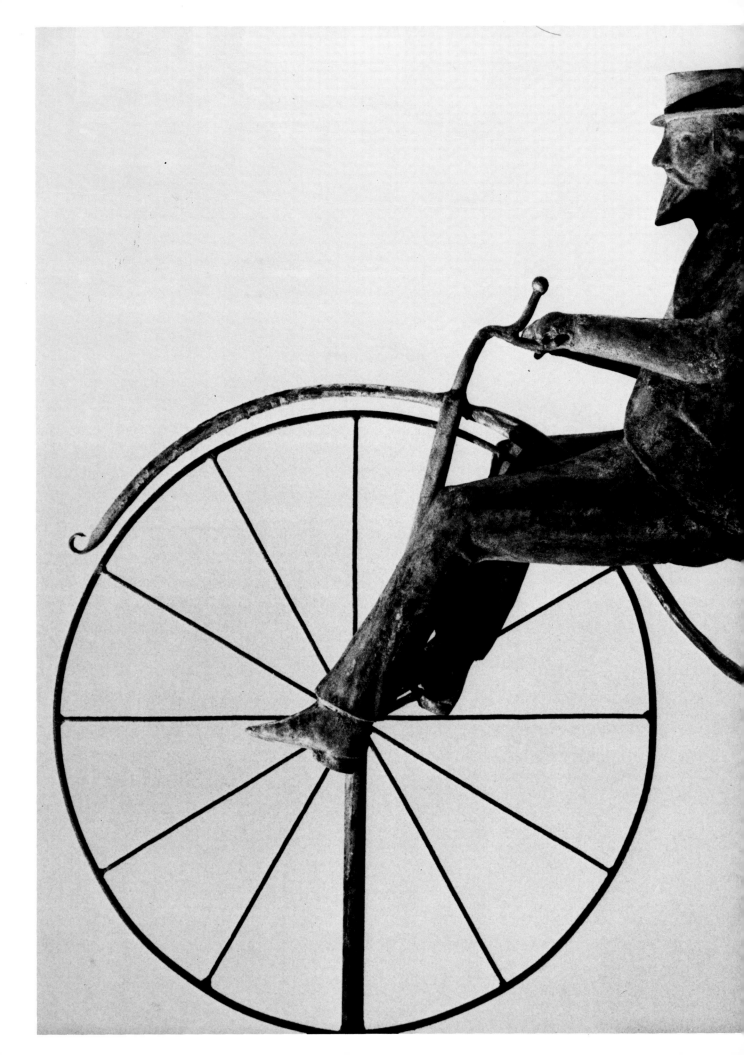

Bicycle Rider: Private Collection.

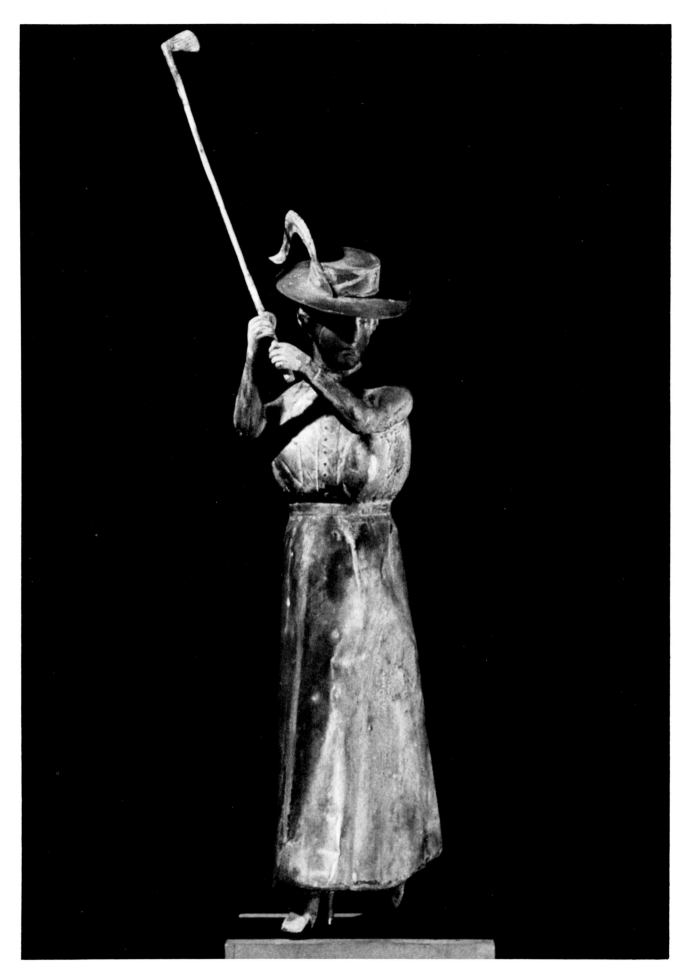

Golfer: Mr. and Mrs. Jacob Kaplan.

Catalog

ILLUSTRATED CATALOGUE

OF

BOSTON COPPER WEATHER VANES,

IRON CRESTING, FINIALS,

LIGHTNING RODS &c.,

MANUFACTURED BY

HARRIS & CO.,

54 BROMFIELD ST., BOSTON, MASS.

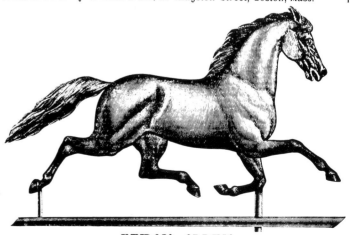

ETHAN ALLEN.

No. 1,	4 feet long		$75 00
" 2,	38 inches long		40 00
" 3,	31 "		25 00
" 4,	29 "	old pattern.	17 00

These prices include Vane, Spire, Letters and Balls all complete.

The prices in this catalogue always include the vane mounted complete as shown on pages 2 and 3, unless otherwise ordered. Our vanes are made of copper in a substantial manner, and so made, as to indicate correctly the direction of the wind; they are gilded with the finest quality of gold leaf, and will stand the weather, and remain bright for many years. In style they are adapted for all kinds of buildings, such as Churches, Public and Private buildings, Stables, Engine Houses, Flag Staffs &c, as will be seen by reference to the following pages.

We also make Vanes of any desired pattern from Architects' plans or other drawings.

Special rates on large contracts for Vanes, Lightning Rods and Cresting.

Estimates furnished on application.

Vanes carefully packed for exportation.

Vanes for home trade are also packed with care and are shipped to all parts of the country.

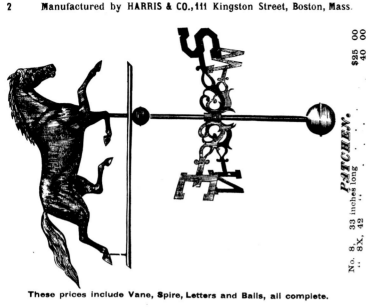

PATCHEN.

No. 8, 33 inches long $25 00
" 8X, 42 " 40 00

SMUGGLER.

These prices include Vane, Spire, Letters and Balls, all complete. These prices include Vane, Spire, Letters and Balls, all complete.

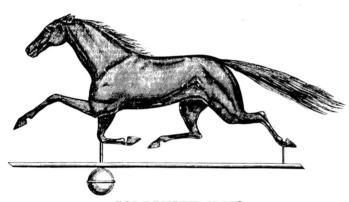

GOLDSMITH MAID.
No. 11, 42 inches long $40 00

DEXTER.

No. 9, and Jockey, full body 28 in. long $35 00
" 9, " Sulkey 40 00
" 9, " Wagon 50 00

These prices include Vane, Spire, Letters and Balls, all complete. These prices include Vane, Spire, Letters and Balls, all complete.

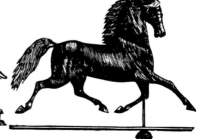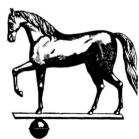

FANCY HORSE.
No. 6, 27 inches long . $28 00

DEXTER.
No. 9, 28 in. long, full body . $25 00
" 5, 29 " " old pattern . 17 00
" 9X, 34 " " . . . 25 00

BLACK HAWK.
No. 10, 25 inches long . $15 00

ARABIAN.
No. 7, 17 inches long . $12 00

These prices include Vane, Spire, Letters and Balls, all complete. These prices include Vane, Spire, Letters and Balls, all complete.

ETHAN ALLEN AND WAGON.

No 3, $50 00
" 3, and sulky 40 00

These prices include Vane, Spire, Letters and Balls, all complete.

PATCHEN AND SULKY.

No. 8, $40 00
" 8, and Wagon, 50 00

These prices include Vane, Spire, Letters and Balls, all complete.

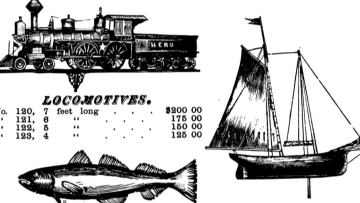

LOCOMOTIVES.

No. 120,	7	feet long	. . .	$200 00
" 121,	6	"	. . .	175 00
" 122,	5	"	. . .	150 00
" 123,	4	"	. . .	125 00

STEAM FIRE ENGINES.

No. 126, with Driver, Fireman and Horses, 7 feet long . $250 00
" 126X, " " " " 5 " . . . 175 00
any size made to order.

These prices include Vane, Spire, Letters and Balls, all complete.

FISH.

No. 131, 30 inches long . . $22 00

YACHT.

No. 112, 27 inches long $25 00
" 110, Ship, 38 in. long 50 00

These prices include Vane, Spire, Letters and Balls, all complete.

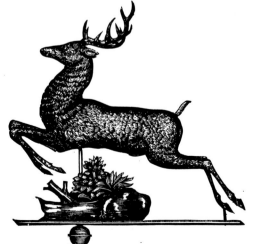

DEER.

No. 30, 31 inches long . . $40 00
" 31, " " " without bush 35 00
These prices include Vane, Spire, Letters and Balls, all complete.

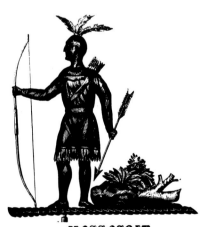

MASSASOIT.

30 inches high $40 00

These prices include Vane, Spire, Letters and Balls, all complete.

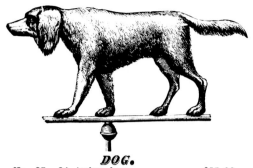

DOG.

No. 37, 34 inches long . . . $25 00

These prices include Vane, Spire, Letters and Balls, all complete.

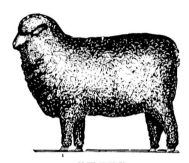

SHEEP.

No. 22, Sheep, 30 inches long . $22 00
" 24, Ram, 30 " " . . 25 00

These prices include Vane, Spire, Letters and Balls, all complete.

OXEN.

No. 13, 33 inches long . . . $40 00
" 14, 25 " 20 00

These prices include Vane, Spire, Letters and Balls, all complete.

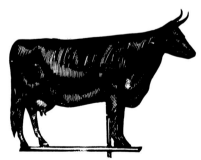

COWS.

No, 17, 33 inches long . . . $40 00
" 18, 25 " 20 00
" 19, full body, 33 inches . . 50 00

These prices include Vane, Spire, Letters and Balls, all complete.

GAME COCKS.

No, 55, 28 inches high . . . $30 00
" 56, full body, 18 inches high 20 00
" 57, 16 inches high 10 00

These prices include Vane, Spire, Letters and Balls, all complete.

ROOSTERS.

No. 52, full body, 33 inches high $40 00
" 54, " 23 " 20 00
" 51, old pattern, 31 " 25 00
These prices include Vane, Spire, Letters and Balls, all complete.

EAGLES.

No. 44, 15 in. spread, $15 0
Banner eagle, 6 " " 3 5

STORK.

No. 59, 24 inches high $25 00

These prices include Vane, Spire, Letters and Balls, all complete.

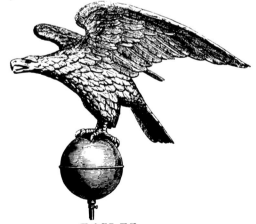

EAGLES.

No. 39, 66 inches spread, $125 00
" 40, 54 " " . 100 00
" 42, 31 " " . 75 00
" 45, 25 " " . . 50 00
" 43, 18 " " . . 25 00
These prices include Vane, Spire, Letters and Balls, all complete.

BOOTS.

No. 161, 20 inches high with No. 44 eagle $28 00
" 162, " " boot alone for sign 10 00

These prices include Vane, Spire, Letters and Balls, all complete.

ARROWS.

No.	89,	62	inches long	$30 00
"	90,	51	"	19 00
"	91,	44	"	16 00
"	92,	37	"	10 00
"	93,	31	"	8 00
"	94,	24	"	6 00
"	95,	18	"	5 00
"	96,	15	"	4 00
"	97,	12	"	

PENS.

No.	100,	50	inches long	$22 00
"	101,	40	"	20 00
"	102,	33	"	15 00
"	104,	28	"	12 00
"	105,	20	"	10 00

These prices include Vane, Spire, Letters and Balls, all complete.

CHURCH VANES.

No. 62, 7 feet long $70 00
" 63, 6 " 60 00

These prices include Vane, Spire, Letters and Balls, all complete.

CHURCH VANES.

No. 61, 8 feet long $85 00
" 64, 5 1-2 " " 50 00
" 65, 5 " " 40 00
" 66, 4 1-2 " " 35 00

These prices include Vane, Spire, Letters and Balls, all complete.

SCROLLS.

No. 76, 42 inches long . $19 00
" 77, 40 " " . . 18 00

No. 78, 38 inches long . $15 50

These prices include Vane, Spire, Letters and Balls, all complete.

SCROLLS.

No, 74, 49 inches long $25 00

No. 75, 45 inches long $23 00

These prices include Vane, Spire, Letters and Balls, all complete.

SCROLLS.

No. 81, 20 in. long $9 00
" 82, 16 " 6 00
" 83, 12 " 5 00

No. 79, 36 inches long $14 50

No. 80, 28 in. long $11 00

These prices include Vane, Spire, Letters and Balls, all complete.

BANNERETS.

No. 87, 30 inches long $20 00
" " 36 " " 30 00
" " 42 " " 40 00
" " 48 " " 50 00
any style made to order.
These prices include Vane, Spire, Letters and Balls, all complete.

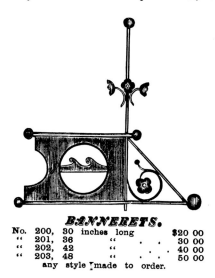

BANNERETS.

No. 200, 30 inches long $20 00
" 201, 36 " " . . 30 00
" 202, 42 " " . . 40 00
" 203, 48 " " . . 50 00
any style made to order.

These prices include Vane, Spire, Letters and Balls, all complete.

INITIAL BANNERETS.

No. 204, 30 inches long . $20 00
" 205, 36 " " . . 30 00
" 206, 42 " " . . 40 00
" 207, 48 " " . . 50 00
any letter made to order.

These prices include Vane, Spire, Letters and Balls, all complete.

BANNERETS,

No 208.

No. 209.

No. 210.

No. 211.

Same sizes and prices as those on pages 29, 30 & 31.
These prices include Vane, Spire, Letters and Balls, all complete.

BANNERETS,

No. 212.

No. 213.

No. 214.

No. 215.

Same sizes and prices as those on pages 29, 30 & 31.
These prices include Vane, Spire, Letters and Balls, all complete.

Copper Balls	
gilded, for	
FLAG POLES &c.	
2 inch	$0 50
3 "	0 70
4 "	1 10
5 "	1 42
6 "	2 00
8 "	3 50
10 "	7 75
12 "	12 00

FLAG.

No. 115, 18 x 12 1-2 in. $20 00

These prices include Vane, Spire, Letters and Balls, all complete.

TO THE ERECTION OF 3

LIGHTNING CONDUCTORS

we give our SPECIAL PERSONAL ATTENTION.

Our conductors are made of $\frac{3}{8}$ square refined iron, galvanized, and are firmly secured to the building, PLAIN, NEAT and PRACTICAL, and in no way mar the architecture of a building. We use no insulators nor fancy patent appliances. The following is from CYCLOPEDIA BRITTANNICA.

"The lines of conduction should be secured immediately against the walls, and not be placed at any distance from the building, or pass through rings of glass, or other insulators, as is sometimes erroneously done.

The notion of keeping the electrical discharge out of the building by insulating the conductor from its walls, is evidently very futile, and can only arise out of false views of the nature of the electrical discharge, which is determined to the earth in a path of least resistance, which the conductor itself supplies, We cannot, therefore, imagine that the electric agency will leave a good, capacious conductor, immediately in its line of action, and in which the resistance is a minimum, to move in a bad conducting circuit, out of that line, in which the resistance is a maximum. But if we were to admit that such an effect were possible, even then it is not to be supposed that a small mass of bad conducting matter, such as a small ring of glass, could arrest such a terrible agency in its onward course. An agency which can shiver immense oak trees, split solid rocks asunder, and break down half a mile thick of air, would scarce be arrested by such an insignificant mass of glass." We shall be pleased at any time to refer to the City Arch't, or Sup't., of Public Buildings of BOSTON, or to the owners of some of the finest residences of NEWPORT, R. I. also to many of our suburban residents.

Orders by mail will receive prompt attention. Contracts made for VANES, LIGHTNING RODS AND CRESTING.

MEDAL FOR

AWARDED ELECTRIC

TO

HARRIS & CO, WIND

BOSTON. **INDICATOR.**

Placing dials inside houses for indicating the direction of the wind has been done frequently, but there are many objections to the arrangement of cog-wheels and pipes or rods with set screws, etc., which are a source of almost constant annoyance. Wheels are unlocking or binding, screws are getting loose, rods and pipes are rattling and squeaking, and every noise from the vane is magnified a hundred per cent. in the house. It also frequently occurs where the dials are wanted that they cannot be run in the old way, owing to the distance and number of corners to be turned, which necessitates the multiplication of wheels and other perplexities. It will be seen at a glance that the INDICATOR shown and described on opposite page, avoids all these objections, as it may be screwed to the wall anywhere and a wire or set of wires run to the vane. It is perfectly noiseless, and there is nothing about it to wear out except the battery, which may be kept in the cellar or other convenient place, and which costs but little to run.

It is just the thing for Hotels, for the convenience of visiting guests.

The cost depends upon its location and will be furnished on application.

HARRIS' ELECTRIC WIND INDICATOR.

We have recently patented a new device for indicating the direction of the wind in the house, without going out of doors.

It can be put in any place desired in a house, and connected by a

small cable with a wind-vane located on any part of the building.

The hand on the dial will move every time the vane moves, showing accurately the direction of the wind and is always reliable.

JUDGES REPORT AT THE MECHANICS FAIR, BOSTON, 1878.

"This instrument is ingeniously and scientifically constructed, so that an electric dial placed in any room will give the exact direction of the wind, as indicated by the vane upon the top of the building. Its advantage over the ordinary mechanical wind indicator consists in the ease with which the electric wires may be carried from the vane to the indicator, however great the distance or difficult the route. A very useful invention. The Executive Committee award a

BRONZE MEDAL."

In addition, we make ALL KINDS of ornamental

COPPER WORK, CRESTING, FINIALS and VANES to order, from

drawings.

The price of CRESTING depends upon quantity, and the style of finish.

In estimating we always include one coat of Metallic Paint on iron work,

unless otherwise advised.

We can decorate cresting with GOLD LEAF, for 10 to 25 cents a foot extra,

according to size.

Estimates furnished on application.

In sending for prices of cresting, state as near as possible how many feet,

and how many finials are wanted.

Bibliography

Bishop, Robert. *American Folk Sculpture,* New York: E.P. Dutton & Co., 1974.

Bishop, Robert. *A Gallery of American Weathervanes & Whirligigs,* New York: E.P. Dutton & Co., 1981.

Cahill, Holger. *American Folk Sculpture.* Newark, N.J.: The Newark Museum, 1931.

Christensen, Erwin O. *Early American Wood Carving.* Cleveland & New York: World Publishing Co. 1952.

Christensen, Erwin O. *The Index of American Design.* New York: Macmillan Company, 1950.

Fitzgerald, Ken. *Weathervanes and Whirligigs.* New York: Clarkson N. Potter, 1967.

Kaye, Myrna. *Yankee Weathervanes.* New York: E.P. Dutton & Co., 1975.

Klamkin, Charles. *Weather Vanes.* New York: Hawthorn Books, 1973.

Lipman, Jean. *American Folk Art in Wood, Metal & Stone.* New York: Pantheon Books, 1948.

Lipman, Jean and Alice Winchester. *The Flowering of American Folk Art.* New York: Viking Press & The Whitney Museum of American Art, 1974.

Little, Nina Fletcher. *Abby Aldrich Rockerfeller Folk Art Collection.* Boston: Little, Brown, 1957.

Winchester, Alice, ed. *The Antiques Treasury.* New York: E.P. Dutton & Co., 1959.